校園武術

SCHOOL WUSHU

U0164803

于存亮 編著

Yu Cunliang Author

香港國際武術文化中心

前 言

武術歷史悠久，源遠流長，是中華民族在長期的生產，生活，斗爭實踐中逐漸發展起來的一項獨特的民族形式體育項目。武術內容豐富多彩，深受國內外廣大人們的喜愛。武術不僅可以強身健體，防身自衛，更能培養人的道德品質和良好的武德、武風、武術禮儀風範。

弟子規原名〈訓蒙文〉，為清朝康熙年間秀才李毓秀所作。其內容採用《論語》學而篇，以三字一句，兩句一韻編纂而成。它是中國傳統的兒童啟蒙教材，能深入淺出地教導為人子弟者關於孝順、友愛、謹慎、誠信、愛人、尊師重道及學習的道理，現時在世界不同的華人地區廣泛流行及普及。

「武術」和「弟子規」、「三字經」等都是中華民族在長期的歷史發展中沉澱下來的文化精髓，也是中華民族流傳後世的精神食糧。對後代影響深遠。俗話說：十年樹木，百年樹人，培養一個人是長時間潛移默化的過程，因而對兒童早期教育尤為重要，要從小就培 養他們孝悌仁愛的品格和奮發進取的精神。

故香港國際武術文化中心董事及技術總鑒于存亮老師攜手中心榮譽顧問、國際著名武術家、 中華武林百杰、武術八段,、原香港武術代表隊總教練于立光老師共同編撰，將「弟子規」、「三字經」、「詩詞」、「道德經」、「詩歌」、「音樂」等同武術結合在一起，創編了既說又練，結合武術的動作和韻律，在練武中既鍛煉了身體又學會了做人道理。我們將它稱謂「弟子規武術」「三字經武術」、「詩詞武術」、「音樂武術」等。

這些武術主要是以長拳和南拳的基本動作，基本技術而組成。教材內容依 據幼兒的心理，生理，興趣等特點編創。主要包括武術的基本手法，幼兒武術操；幼兒長拳；兒童拳及簡單安全的器材（扇、筆、環等）。動作簡練，易懂易學，動作緊湊，流暢，活潑，以一種輕松的方式既能記憶動作，又能記憶「弟子規」、「三字經」等，深受廣大兒童喜愛。

Preface

Wushu has a long history. It is a unique national form of sports that the Chinese nation has gradually developed in the long-term production, life, struggles, and practices. The content of Wushu is rich and colorful, and it is deeply loved by people all around the world. Not only strengthening the body and for self-defense, Wushu can also cultivate people's moral quality and good Wushu ethics, Wushu style, and Wushu etiquette.

The original name of Di Zi Gui (The Rules of Students), was "Xun Meng Wen", written by Li Yuxiu, a talented scholar during the KangXi period of the Qing Dynasty. Its content adopts the Xueer chapter in Lunyu (The Analects of Confucius), compiles it with three characters as a one sentence and two sentences with one rhyme. It is a traditional Chinese teaching material for children's enlightenment. It can teach children about filial piety, friendship, prudence, integrity, love, respect for teachers and learning principles in simple terms. It is now widely popular in different Chinese regions in the world.

"Wushu", "The Rules for Students" and "Three Character Classics" are all the cultural essence of the Chinese nation that has been precipitated in the long-term historical development, and they are also the spirit that the Chinese nation has passed down to posterity. It has profound impacts on future generations. As the saying goes: It takes ten years to nurture a tree, but a hundred years to build a man, cultivating a person is a long and subtle process. Therefore, it is particularly important for early childhood education, we must cultivate their filial and benevolent character, and enterprising spirit from an early age.

Hence, the administrative and technical director of the Hong Kong International Wushu Cultural Centre, Mr Yu Cunliang, joined hands with the center's honorary consultant, a famous Chinese martial artist, one of the hundred masters of Chinese Wushu, the eighth stage of Wushu, the former head coach of the Hong Kong Wushu Team, Yu Liguang and co-edited this book. They combined "The Rules for Students", "Three Character Classics", "Poetry", "Dao De Jing", "Songs", "Music" with Wushu, creating both speaking and practicing movements and rhythms with Wushu, having the body trained as well as learning the principles of being a human in the practices in Wushu. We named it "Wushu with The Rules for Students", "Wushu with Three Character Classics", "Wushu with Poetry", and "Wushu with Music", etc.

These martial arts are mainly composed of the basic movements and basic techniques of Changquan and Nanquan. The content of the teaching materials is based on the characteristics of children's psychology, physiology, and interests. It mainly includes the basic techniques of Wushu, Wushu Exercises for Children; Changquan for Children; Fist for Children; and simple and safe equipment (fans, pens, rings, etc.). The movements are concise, easy to understand and learn, compact, smooth, and lively. They can not only memorize movements in a relaxed way, but also memorize "Rules for Students" and "Three Character Classics", etc., which are very popular among children.

作者介紹

姓　　　名：于　存亮
生年月日：１９７２年６月８日
出　生　地：中國黑龍江省哈爾濱市
最終學歷：碩士（MASTER）
現　住　所：香港

　　于存亮 1972 年 6 月 8 日出生於中國哈爾濱的一個武術世家。父親于立光是原香港武術代表隊總教練，原哈爾濱師範大學教授，中華武林百傑，八段著名武術家。自幼受父親的熏陶影響，熱愛武術運動。小時參加市青少年業餘體校武術班，進行系統的學習訓練。曾多次參加省，市的武術比賽取得第一名的優異成績。

　　1991 年考入上海體育學院武術系（本科）武術專業。在校期間獲得了一級武士和二級裁判。1995 年 7 月畢業，取得學士學位。同年 9 月進入黑龍江省中醫藥大學體育教研部擔任教師。除教授武術普修課和理論課外，還負責院武術代表隊的統領及訓練工作。在職期間，院代表隊選手在全國大學生運動會的武術比賽中，獲得太極拳金牌的優異成績。為學院爭得了榮譽，受到學校的表彰。

　　1997 年 5 月為繼續深造，豐富自己的學業，拓寬知識範圍，東渡日本，於 1999 年 4 月考入了在日本體育學部著名的中京大學體育學研究科。主要學習和研究了體育原論，概論，體育訓練學，體育管理及經營學等。以優異的成績獲得了碩士學位。

　　畢業後 2001 年 9 月就職於名古屋市內的一所 24 小時救急病院，擔任事務長

助理工作，主要負責管理院內各項事務工作。同時兼任醫療保健太極氣功指導師等。

除此之外，利用業余時間還繼續從事武術教育事業，傳播中華傳統文化。2001 年 9 月受日本太極拳協會的邀請擔任講師。2006 年受日本武術協會邀請為日本青少年代表隊的特聘教練，為日本培養精英青少年，並在 2010 年第三屆世界青少年武術錦標賽上學生中井取得了男子 B 組長拳金牌，為日本增光添榮。同時在 2005 年 9 月受日本各務原市市委的邀請任成人武術講師;2005 年 4 月受聘於社會福祉法人新生保育園任學前儿童武術教師;2007 年 4 月至 2008 年 3 月擔任名古屋市ビジネス專業高等學校的武術專業課教師。同年創辦了「于存亮太極拳協會」，多年來為推廣中國武術文化，增強人民體質，培養武術人才做了大量的工作和貢獻。2011 年 9 月來到香港繼承父業，同創「香港國際武術文化中心」，繼續傳播中國武術。除在港各中小學及幼稚園教授武術外，還受武術中心和香港大學所邀，擔任顧問及大學生武術講師。

並從 2012 年開始受聘為弘立書院校武術隊的總教練，幾年時間為弘立書院培養了幾十名全港武術冠軍和國際冠軍，並為香港武術代表隊培養了譚希臨（2016 年世界青少年武術錦標賽劍術銀牌），孫慧霖，蔡騫舜，何曼沛，許立恆，James 等港代表隊隊員，在港期間受到各方面的認可和好評，現在繼續在港，帶領中心學員及學校學員參加國內外各大比賽及集訓等。將多年來所學到的管理和技術知識，積累的經驗奉獻給香港武術事業。

Profile

Name： Yu Cun Liang
Birth Date : 8th June, 1972
Birth Place： Harbi, China
Education Degree : Master
Now Living in : Hong Kong, China

 Yu Cun Liang was born on June 8, 1972 in Harbin, China, in family of martial arts. His father, Yu Li Guang, was the former head coach of the Hong Kong Wushu Team, a former professor of the Harbin University, a Chinese martial arts master, and a famous martial artist of the Eight Chapter Style. Influenced by his father since childhood, he loves martial arts. He participated in a martial arts class of the city youth amateur sports school for a few hours, and conducted systematic studies and training. He has repeatedly participated in martial arts competitions in the provinces and cities and won the first prize.

 In 1991, he was admitted to the Martial Arts Department of the Shanghai Sports University. During his studies, he won the first-level samurai and the second-level referee degree, graduating in July, 1995 with a bachelor's degree. In September of the same year, he entered the Sports Teaching and Research Department of Hei Long Jiang University of Traditional Chinese Medicine as a teacher. In addition to teaching general martial arts and theoretical classes, he was also responsible for the leadership and training of the martial arts team. During his teaching period, the members of the college representative team won gold medals in Tai Chi in the martial arts competitions of the National University Games. He won the honor of the college and received an award from the school.

 In May, 1997, in order to continue and enrich his studies, and in addition broaden his scope of knowledge, he traveled to Japan. In April, 1999, he was admitted to the Graduate School of Physical Education of Chukyo University, a well-known faculty of physical education in Japan. He mainly studied and researched sports theories, reviews, sports training, sports management and business management. He obtained a master's degree with honors.

 After graduating in September, 2001, he worked a 24-hour shift in a hospital's Emergency Department in Nagoya City as an assistant to the general secretary and being

mainly responsible for managing various incidents in the hospital. At the same time, he also served as a health care Tai Chi Qi Gong instructor.

In addition, in his spare time, he continued to engage in martial arts education and spreading traditional Chinese culture. In September, 2001, he was invited by the Japanese Tai Chi Association as a lecturer. In 2006, he was invited by the Japanese Wushu Association as a special coach for the Japanese Youth Team to train young people for Japan. In 2010, a student Nakai won the Men's Group B Chan Quan gold medal at the 3rd World Youth Wushu Championships, adding glory to Japan. At the same time, he was invited to be an adult martial arts instructor by the municipal party committee of Kakamigahara, Japan in September, 2005; in April, 2005, he was employed as a martial arts teacher for pre-school children in a social welfare corporation freshman nursery school; from April, 2007 to March, 2008, he served as a martial arts teacher in Nagoya City. He was a martial arts major in a junior college. In the same year, the "Yu Cun Liang Taijiquan Association" was founded. Over the years, he has done a lot of work and contributions to promote Chinese martial arts culture, enhancing people's physical fitness, and cultivating martial arts talents. In September, 2011, he came to Hong Kong to inherit his father's business, the "Hong Kong Martial Arts International Cultural Center" and continued to spread Chinese martial arts. In addition to teaching martial arts in Hong Kong schools and kindergartens, he was also invited by the Wushu Center and the University of Hong Kong to serve as a consultant and a martial arts lecturer for college students.

Since 2012, he has been hired as the head coach of the martial arts team of Hong Li Shu Academy. Over the years, he has trained dozens of Hong Kong martial arts champions and international champions for Hong Li Shu Academy, and trained Tan Xi Lin for the Hong Kong Wushu Team (2016 Swordsmanship at the World Youth Wushu Championships), Sun Hui Lin, Cai Qian Shun, He Man Pei, Xu Lin Heng, James and other members of the Hong Kong representative team. They were recognized and praised by various parties during their stay in Hong Kong. Now they continue to be in Hong Kong, leading the center students and school students to participate in various local and foreign big competitions and training camps, dedicating the management and technical knowledge. Experience accumulated over the years to the cause of Hong Kong martial arts.

2019 年 4 月日本交流

帶領中心青少年武術隊取得輝煌成績

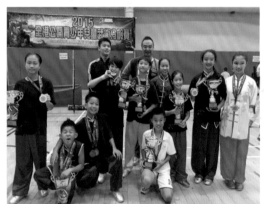

帶領中心學員取得個人佳績

同傑出青年主席周定宇合影

同全日本太極拳協會理事長（中，二宮恒夫）等合影

日本著名教練國際級裁判中村剛（左一）和原日本代表隊選手世界冠軍一起合影

同日本愛知大學武術隊總教練及外交部部長合影 日本交流訓練

香港國際武術文化中心開業 十四屆香港國際武術比賽

香港公開分齡賽 同中心學員譚希臨（香港武術代表隊隊員，世界青少年武術錦
標賽亞軍得主）

開業典禮剪彩

同中心學員何曼佩

同中心學員許立恆

中心學員小小年紀成績非凡

同中心學員唐子堯
（香港武術代表隊隊員）

香港青少年武術比賽

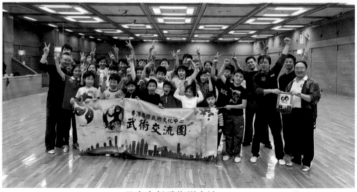

日本中部武術隊交流

日本武術交流活動

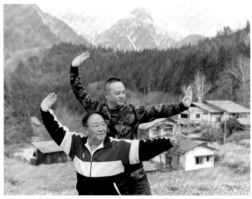

同父親

同中心學員盧子澄

同世界著名武術家，中華武林百傑，
第一批國際級裁判，原香港武術代表
隊總教練于立光（父）合影。

香港國際武術邀請賽

中心搬遷開業典禮

香港青少年武術比賽

手型 Hand forms

武術禮儀

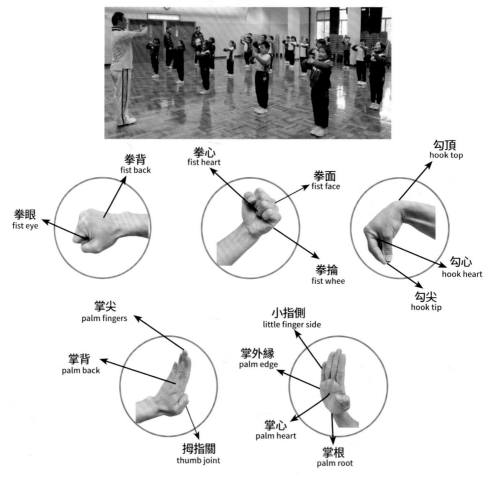

拳背
fist back

拳心
fist heart

拳面
fist face

勾頂
hook top

拳眼
fist eye

拳搵
fist whee

勾心
hook heart

勾尖
hook tip

掌尖
palm fingers

小指側
little finger side

掌背
palm back

掌外緣
palm edge

掌心
palm heart

掌根
palm root

拇指關
thumb joint

抱拳禮： 右手为拳，左手为掌，将拳面放在左掌心，两臂成圆弧，高于胸平。

Salute with fist: Form a fist with right hand, form a palm with left hand, attach the face of the fist to the center of left palm, form a round arc with both arms that level with the chest.

拳： 四指併攏卷握，拇指屈壓于食指中指第二指節上，拳面要平，任何四指不准凸出拳面，拳心向下為平拳，拳眼向上為立拳。

Fist: roll up and hold four fingers closely together, the thumb is flexed on the second knuckle of the index finger and the middle finger. The face of fist should be flat. Any four fingers are not allowed to protrude from the face of fist.

掌： 四指併攏伸直向後伸張，拇指彎曲緊扣于食指側。

Palm: Four fingers are closely together and stretched out straight back, with the thumb bent and clasped tightly on the side of the index finger.

勾： 五指撮攏成勾，屈腕。

Hook: the fingers are gathered into a hook, with the wrist bent.

馬步：兩腳平行開立約三腳寬，兩腿屈膝下蹲，大腿接近水平，兩膝約垂直於腳尖，挺胸，立腰。

Horse stance:the feet are about three or four feet apart, toes facing forwards, knees bent in a half-squat, chest out, lower back upright.

弓步：前腿屈膝半蹲，大腿接近水平，膝蓋約垂直腳面；後腿挺膝伸直，腳尖內扣，兩腳全腳掌著地，挺胸，立腰。

Bow stance:The front foot is turned slightly inwards, the foot flat on the ground, the knee bent in a half-squat, the thigh level, so the knee is approximately perpendicular to the top of the foot,the foot flat on the ground, the upper body is facing forwards,chest out, lower back upright.

歇步：兩腿交叉屈膝全蹲，前腳全腳掌著地，腳尖外展；後腳跟離地，臀部外側緊貼後小腿，挺胸、立腰、兩腿貼緊。

Rest stance:cross legs, bend knees and squat fully, front foot flat on the ground and toes turned outwards; rear heel off the ground and the buttocks close to the rear calf, chest out, lower back upright, and keep legs tight together.

虛步：後腳尖斜向前，屈膝半蹲，大腿接近水平，全腳掌著地；前腿微屈，腳面繃緊，腳尖虛點地面。

Empty stance:The toes of the rear foot are turned obliquely forward, the knee bent in a half-squat, the thigh close to level, and the foot flat on the ground; the front leg is slightly bent, the top of the foot taught, and the toes rest emptily on the ground.

僕步：一腿全蹲，大腿和小腿靠緊，臀部接近小腿，全腳掌著地，膝于腳尖稍外展；另一腿平鋪接近地面，全腳掌著地，腳尖內扣。

Drop stance:one leg squats, thigh and calf close together, buttocks close to the calf, foot flat on the ground, knee and toes slightly turned outwards; the other leg is close to the ground, foot flat on the ground, the toes turned inwards.

幼兒南拳操

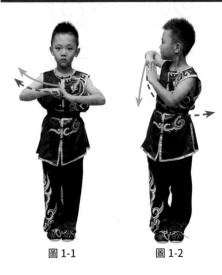

圖 1-1　　　　　圖 1-2

❀預備勢：抱拳禮（圖 1-1）
　Ready posture: Salute with fist (Fig. 1-1)

❀右手拳，置于右胸前，拳心向下，拳面朝前。左掌置右拳面前，掌心對拳面。目視右側方（圖 1-2）。

Right hand with fist, place it in front of the right chest, the center of fist faces down, the face of fist faces forward. Place the left palm in front of the right fist, the center of palm faces the face of fist. Look to the right (Fig. 1-2).

❀身體直立，右拳向右肩前衝出；左掌向左肩前立掌推出；頭甩向前，目視前方（圖 1-3）。

Body upright, punch the right fist forward to the right shoulder; erect and push the left palm forward to the left shoulder; swing the head forward, look forward (Fig. 1-3).

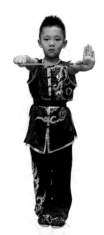

圖 1-3

❀左手變拳，兩肘屈肘，兩拳平擺於胸前，拳心向下，拳眼對胸，目視前方（圖 1-4）。

Change the left hand to a fist, bend both elbows, place the fists in front of the chest horizontally, the center of fists face down, the eye of fists face the chest, look forward. (Fig. 1-4)

❀兩肘夾頭，兩拳旋轉經胸前，拳背向下砸出，收抱於腰間，拳心向上，甩頭向左，目視前方（圖 1-5）。

Lock the head with both elbows, rotate both fists through the front of the chest, downward hammer strike with the back of the fists, withdraw them to the sides of the waist, the center of fists face up, swing the head to the left, look forward. (Fig. 1-5)

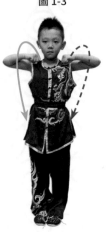

圖 1-4

✿ 重複之前動作，左手拳，置于左胸前，拳心向下，拳面朝前。右掌置左拳面前，掌心對拳面。目視左側方（圖 1-6）。

Repeat the previous movement, left hand with fist, place it in front of the left chest, the center of fist faces down, the face of fist faces forward. Place the right palm in front of the left fist, the center of palm faces the face of fist. Look to the left (Fig. 1-6).

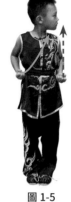

圖 1-5

✿ 身體直立，左拳向左肩前衝出；右掌向右肩前立掌推出；頭甩向前，目視前方（圖 1-7）。

Body upright, punch the main fist, left fist, forward to left shoulder, erect and push the right palm forward to the right shoulder; swing the head forward, look forward (Fig. 1-7).

✿ 右手變拳，兩肘屈肘，兩拳平擺於胸前，拳心向下，拳眼對胸，目視前方（圖 1-8）。

Change the right hand to a fist, bend both elbows , place the fists in front of the chest horizontally, the center of fists face down, the eye of fists face the chest, look forward. (Fig. 1-8)

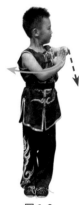

✿ 兩肘夾頭，兩拳旋轉經胸前拳背向下砸出，收抱於腰間，拳心向上，甩頭向右，目視前方（圖 1-9）。

Lock the head with both elbows, rotate both fists through the front of the chest, downward hammer strike with the back of the fists, withdraw them to the sides of the waist, the center of fists face up, swing the head to the right, look forward. (Fig. 1-9)

圖 1-6

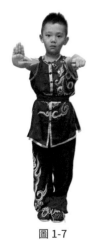

圖 1-7

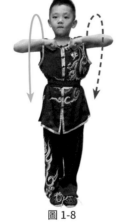

圖 1-8

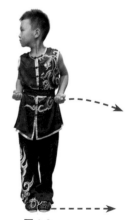

圖 1-9

要求：衝拳，推掌于甩頭要同時進行；兩臂屈肘時要快速，反砸拳要有力。

Requirements: Quickly bend the elbows when swaying the arms to the front right; punch fist, push palm, and swing head at the same time.

幼兒南拳操

第二節 左右弓步推虎爪
Section 2 Left and right bow stance pushing tiger-claw hand

🌸 左腳向左上步，兩腿屈膝，成半馬步，左手變虎爪劃弧向下，向前按，爪心朝下。右手變虎爪收抱右腰側，爪心朝上，目視左爪（圖 2-1）。

Left foot steps to the left, bend both knees, form a semi-horse stance, change the left hand to a tiger-claw hand and arc downward, press forward, with the center of the claw faces down. Change the right hand to a tiger-claw hand and withdraw it to the right of the waist, the center of the claw faces up, look at the left claw (Fig. 2-1).

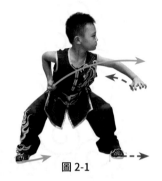

圖 2-1

🌸 右腿蹬直，左腿屈膝，成左弓步；右爪向前衝出，爪心向前。左爪收於右肘下側，爪心朝下。目視右爪（圖 2-2）。

Straighten the right leg, bend the left knee, form a left bow stance; punch the right claw forward, the center of claw faces forward. Withdraw the left claw under the right elbow, the center of claw faces down. Look at the right claw (Fig. 2-2).

🌸 左腳稍回收內扣，兩腿站直。右爪收至右肩前，爪心朝前。左爪向前推出，爪心朝前，目視前方（圖 2-3）。

Slightly withdraw and buckle the left foot, two legs stand straight. Withdraw the right claw to the front of the right chest, the center of claw faces forward. Push the left claw forward, the center of claw faces forward, look forward (Fig. 2-3).

🌸 兩爪變拳收抱於腰間，拳心向上，目視前方（圖 2-4）。

Change both claws to fists and withdraw them to the sides of the waist, the center of fists face up, look forward (Fig. 2-4).

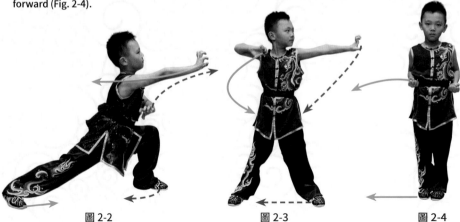

圖 2-2　　　　　　　　圖 2-3　　　　　　　　圖 2-4

✿ 右腳向右上步，兩腿屈膝，成半馬步，右手變虎爪划弧向下，向前按，爪心朝下。目視右爪（圖 2-5）。

Right foot steps to the right, bend both knees, form a semi-horse stance, change the right hand to a tiger-claw hand and arc downward, press forward, with the center of the claw faces down. look at the right claw (Fig. 2-5).

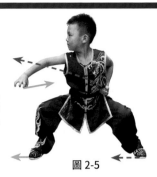

圖 2-5

✿ 左腿蹬直，右腿屈膝，成右弓步；左爪向前衝出，爪心向前。右爪收於左肘下側，爪心朝下。目視左爪（圖 2-6）。

Straighten the left leg, bend the right knee, form a right bow stance; punch the left claw forward, the center of claw faces forward. Withdraw the right claw under the left elbow, the center of claw faces down. Look at the left claw (Fig. 2-6).

✿ 右腳稍回收內扣，兩腿站直。左爪收至左肩前，爪心朝前。右爪向前推出，爪心朝前，目視前方（圖 2-7）。

Slightly withdraw and buckle the right foot, two legs stand straight. Withdraw the left claw to the front of the left chest, the center of claw faces forward. Push the right claw forward, the center of claw faces forward, look forward (Fig. 2-7).

✿ 兩爪變拳收抱於腰間，拳心向上，目視前方（圖 2-8）。

Change both claws to fists and withdraw them to the sides of the waist, the center of fists face up, look forward (Fig .2-8).

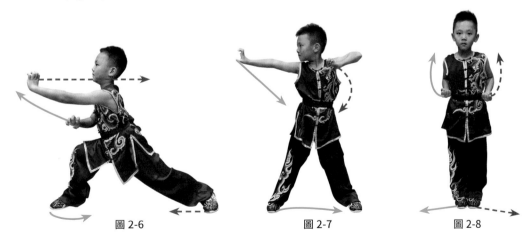

圖 2-6　　　　　圖 2-7　　　　　圖 2-8

要求：推爪與收爪應同時進行，兩腳內扣時腳尖朝前。

Requirements: push claw and withdraw claw at the same time, the tiptoes point to the front when they are buckled.

幼兒南拳操

❀ 兩腳跳左右分開，屈膝半蹲成馬步，兩手變一字掌向胸前推出，一字掌心向前，指尖向上。目視前方（圖 3-1）。

Jump and separate both feet, bend the knees to form a horse stance, change both hands to horizontal palms and push them forward in the front of the chest, the center of horizontal palms face forward, the fingertips face up. Look forward (Fig .3-1).

❀ 兩臂屈肘上抬至肩上，兩手指置頭側後，掌心朝上，掌指朝後。目視左手（圖 3-2）。

Bend both elbows and lift them up to the shoulder, place both hands behind the head, the center of palms face up, the fingers of palms face backward. Look at the left hand (Fig .3-2).

❀ 兩臂屈肘向前，向下，向後沉挫，使單指落於腰兩側，掌心朝下，指尖朝前。目視右手（圖 3-3）。

Bend both elbows and sink forward, downward, and backward, so that the single fingers drop to the sides of the waist, the center of palms face down, the fingertips face forward. Look at the right hand (Fig .3-3).

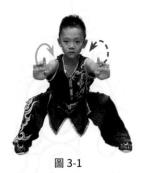
圖 3-1

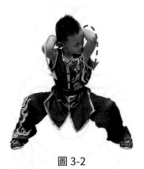
圖 3-2

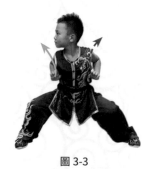
圖 3-3

❀ 兩掌向前推出，指尖于眼同高。兩手間距離略寬於肩，目視前方（圖 3-4）。

Push both palms forward, the fingertips are level with the eyes. The distance between two hands is slightly wider than the shoulder, look forward (Fig. 3-4).

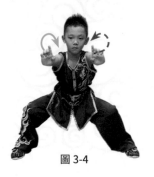
圖 3-4

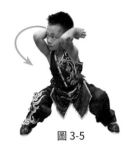

✿ 兩臂屈肘上抬至肩上，兩手指置頭側後，掌心朝上，掌指朝後。目視右手（圖 3-5）。

Bend both elbows and lift them up to the shoulder, place both hands behind the head, the center of palms face up, the fingers of palms face backward. Look at the right hand (Fig .3-5).

圖 3-5

✿ 兩臂屈肘向前，向下，向後沉挫，使單指落於腰兩側，掌心朝下，指尖朝前。目視左手（圖 3-6）。

Bend both elbows and sink forward, downward, and backward, so that the single fingers drop to the sides of the waist, the center of palms face down, the fingertips face forward. Look at the left hand (Fig .3-6).

✿ 兩掌向前推出，指尖于眼同高。兩手間距離略寬於肩，目視前方。（圖 3-7）

Push both palms forward, the fingertips are level with the eyes. The distance between two hands is slightly wider than the shoulder, look forward (Fig. 3-7).

✿ 身體跳起并步直立，兩手變拳收抱於腰間，拳心向上，目視前方（圖 3-8）。

Change both hands to fists and withdraw them to the sides of the waist, the center of fists face up, look forward (Fig .3-8).

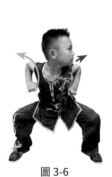

圖 3-6

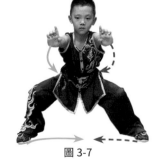

圖 3-7

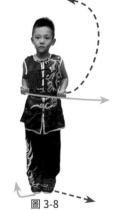

圖 3-8

要求: 臂的沉挫，單指向前推，都需要使臂部肌肉保持適度的緊張性，以獲得緩緩用勁的效果。沉橋屈臂，使前臂由上向下挫沉，力達前小臂。

Requirements: The sinking of the arm and the forward pushing of the single finger need to keep the arm muscles moderately tense in order to obtain the effect of slow exertion. Sinking bridge: Bend the arm, so that the forearm sinks from top to bottom, the force reaches the forearm.

幼兒南拳操

第四節 左右虎爪蹬腳
Section 4 Left and right tiger-claw hand heel kicking

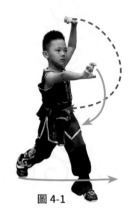

圖 4-1

🐾 左腳向左斜前方（45度左右）上步曲膝，右腳跟抬起，右膝往下壓彎曲，于左腳成麒龙步。左手變虎爪上架，爪心向上。右手變虎爪推於右肩前，目視前方（圖4-1）。

Left foot steps diagonally (about 45 degrees) to the front left and bend the knee, lift the right heel, press and bend the right knee downward, form a follow-up step with the left foot. Change the left hand to a tiger-claw hand and block it over the head, with the center of claw facing up. Change the right hand to a tiger-claw hand and push it to the front of the right shoulder, look forward (Fig .4-1).

🐾 右腳勾腳尖向斜前方蹬出，兩手虎爪收抱於右腰前，兩爪心向對，目視前方（圖4-2）。

Cock the right tiptoes and kick it to the diagonal front with the heel, withdraw both tiger-claw hands to the front of the right waist, the center of the claws face each other, look forward (Fig .4-2).

🐾 右腳退回成麒龙步，兩爪退回成架爪推爪（圖4-3）。

Withdraw the right foot to form a follow-up step, withdraw both claws to form a blocking claw pushing claw (Fig .4-3).

🐾 兩爪變拳收抱於腰間，拳心向上，目視前方（圖4-4）。

Change both claws to fists and withdraw them to the sides of the waist, the center of fists face up, look forward (Fig .4-4).

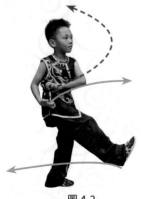

圖 4-2

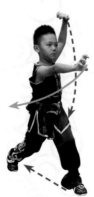

圖 4-3

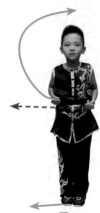

圖 4-4

✤右腳向右斜前方（45度左右）上步曲膝，左腳跟抬起，左膝往下壓彎曲，于右腳成麒龙步。右手變虎爪上架，爪心向上。左手變虎爪推於左肩前，目視前方（圖4-5）。

Right foot steps diagonally (about 45 degrees) to the front right and bend the knee, lift the left heel, press and bend the left knee downward, form a follow-up step with the right foot. Change the right hand to a tiger-claw hand and block it over the head, with the center of claw facing up. Change the left hand to a tiger-claw hand and push it to the front of the left shoulder, look forward (Fig .4-5).

✤左腳勾腳尖向斜前方蹬出，兩手虎爪收抱於左腰前，兩爪心向對，目視前方（圖4-6）。

Cock the left tiptoes and kick it to the diagonal front with the heel, withdraw both tiger-claw hands to the front of the left waist, the center of the claws face each other, look forward (Fig .4-6).

✤左腳退回成麒龙步，兩爪退回成架爪推爪（圖4-7）。

Withdraw the left foot to form a follow-up step, withdraw both claws to form a blocking claw pushing claw (Fig .4-7).

✤兩爪變拳收抱於腰間，拳心向上，目視前方（圖4-8）。

Change both claws to fists and withdraw them to the sides of the waist, the center of fists face up, look forward (Fig .4-8).

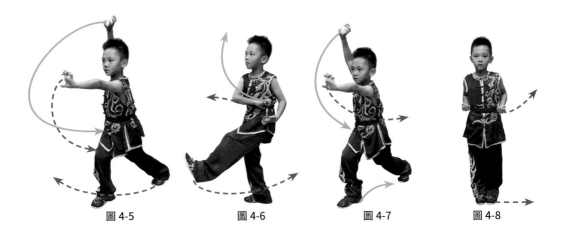

圖4-5　　　　　圖4-6　　　　　圖4-7　　　　　圖4-8

要求：蹬腳時力達腳跟，架爪推爪蹬腳同時進行。

Requirements: The force reaches the heel in the heel kicking movement, block palm, push palm, and heel kick at the same time.

幼兒南拳操

<div>

第五節 弓馬步轉換
Section 5 Changing in bow stance and horse stance

</div>

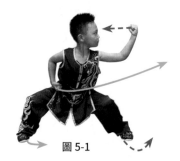

圖 5-1

🌼 左腳向左側上步成馬步，左手屈肘向左側格出，左手拳心向內，肘尖向下（圖 5-1）。

Left foot steps to the left to form a horse stance, bend the left elbow and block it to the left, the center of the left fist faces inside, the tip of the elbow faces down (Fig .5-1).

🌼 左腳向左前方略上步，右腿蹬直變左弓步，右手拳向左前方衝出，左手格肘不變，目視前方（圖 5-2）。

Left foot slightly steps to the front left, straighten the right leg to form a left bow stance, punch the right fist forward to the front left, remain the left hand blocking elbow unchanged, look forward (Fig .5-2).

🌼 左腳略回收腳尖內扣變馬步，左手變立拳向左前衝出，右手拳收回腰間變馬步左衝拳，目視左拳（圖 5-3）。

Slightly withdraw and buckle the left foot to form a horse stance, change the left hand to an erecting fist and punch it forward to the front left, withdraw the right fist to the side of the waist and change to a horse stance with left punching fist, look at the left fist (Fig .5-3).

🌼 左腳收回靠攏右腳並步站直，兩拳收抱於腰間，目視前方（圖 5-4）。

Withdraw the left foot close to the right foot and stand straight with folding stance, withdraw both fists to the sides of the waist, look forward (Fig .5-4).

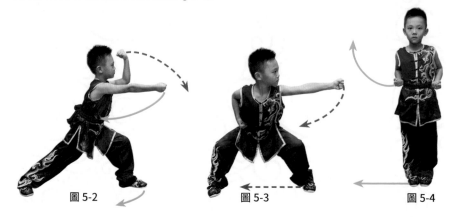

圖 5-2 　　　　圖 5-3 　　　　圖 5-4

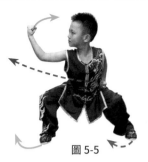

✿ 右腳向右側上步成馬步，右手屈肘向右側格出，右手拳心向
內，肘尖向下（圖 5-5）。

Right foot steps to the right to form a horse stance, bend the right elbow and block it to the right, the center of the right fist faces inside, the tip of the elbow faces down (Fig .5-5).

圖 5-5

✿ 右腳向右前方略上步，左腿蹬直變右弓步，左手拳向右前方衝出，右手格肘不變，目視前方（圖
5-6）。

Right foot slightly steps to the front right, straighten the left leg to form a right bow stance, punch the left fist forward to the front right, remain the right hand blocking elbow unchanged, look forward (Fig .5-6).

✿ 右腳略回收腳尖內扣變馬步，右手變立拳向右前衝出，左手拳收回腰間變馬步右衝拳，目
視右拳（圖 5-7）。

Slightly withdraw and buckle the right foot to form a horse stance, change the right hand to an erecting fist and punch it forward to the front right, withdraw the left fist to the side of the waist and change to a horse stance with right punching fist, look at the right fist (Fig .5-7).

✿ 右腳收回靠攏左腳並步站直，兩拳收抱於腰間，目視前方（圖 5-8）

Withdraw the right foot close to the left foot and stand straight with folding stance, withdraw both fists to the sides of the waist, look forward (Fig .5-8).

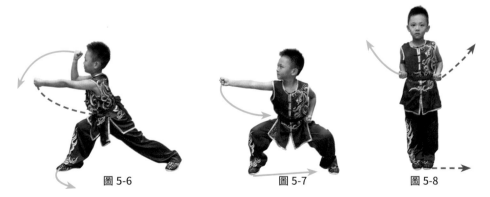

圖 5-6 　　　　　　　圖 5-7 　　　　　　　圖 5-8

要求：弓步轉換成馬步時，兩腳尖內扣。馬步轉換成弓步時，後腿蹬直，腳尖內扣，蹬腳跟。

Requirements: When changing the bow stance to a horse stance, buckle the tiptoes of both feet. When changing the horse stance to a bow stance，straighten the rear leg, buckle the tiptoes and cock the foot in heel kick.

幼兒南拳操

第六節 左右掛蓋
Section 6 Left and right down-stroke crossing

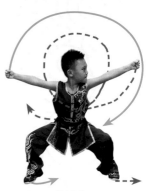

❀ 左腳向左側上步成馬步，兩拳向兩側衝出，拳心向下，甩頭看左，目視左拳（圖 6-1）。

Left foot steps to the left to form a horse stance, punch both fists to both side, the center of fists face down, swing the head to the left, look at the left fist (Fig .6-1).

圖 6-1

❀ 左腳向左前方略上步變左弓步，左手拳反轉拳背向下掛置左側斜下方，右手拳經頭上 , 向左前方拳心向下掄蓋至左髖前，目視前方（圖 6-2）。

Left foot slightly steps to the front left to form a left bow stance, reverse the left fist with the back of the fist facing down and hang it diagonally to the lower left, right fist downward hanging and stroking through the head to the front left and till the front of the left hip, with the center of fist facing down, look forward (Fig .6-2).

❀ 左腳內扣回收成馬步，右手拳再經頭上還原至右側衝拳位置，左手拳也還原至左側衝拳位置（圖 6-3）。

Buckle and withdraw the left foot to form a horse stance, revert the right fist to the punching position through the head, and also revert the right fist to the punching position (Fig .6-3).

❀ 左腳收回靠攏右腳並步站直，兩拳收抱於腰間，目視前方（圖 6-4）。

Withdraw the left foot close to the right foot and stand straight with folding stance, withdraw both fists to the sides of the waist, look forward (Fig .6-4).

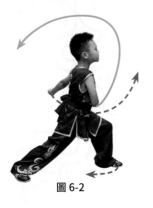
圖 6-2

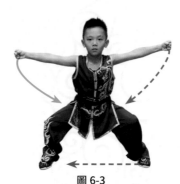
圖 6-3

圖 6-4

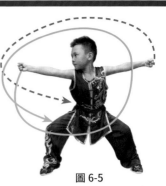

❀ 右腳向右側上步成馬步，兩拳向兩側衝出，拳心向下，甩頭
看右，目視右拳（圖 6-5）。

Right foot steps to the right to form a horse stance, punch both fists to both side, the center of fists face down, swing the head to the right, look at the right fist (Fig .6-5).

圖 6-5

❀ 右腳向右前方略上步變右弓步，右手拳反轉拳背向下掛置右側斜下方，左手拳經頭上向右前方
拳心向下掄蓋至右髖前，目視前方（圖 6-6）。

Right foot slightly steps to the front right to form a right bow stance, reverse the right fist with the back of the fist facing down and hang it diagonally to the lower right, left fist downward hanging and stroking through the head to the front right and till the front of the right hip, with the center of fist facing down, look forward (Fig .6-6).

❀ 右腳內扣回收成馬步，左手拳再經頭上還原至左側衝拳位置，右手拳也還原至理由側衝拳位（圖
6-7）。

Buckle and withdraw the right foot to form a horse stance, revert the left fist to the punching position through the head, and also revert the left fist to the punching position (Fig .6-7).

❀ 右腳收回靠攏左腳並步站直，兩拳收抱於腰間，目視前方（圖 6-8）。

Withdraw the right foot close to the left foot and stand straight with folding stance, withdraw both fists to the sides of the waist, look forward (Fig .6-8).

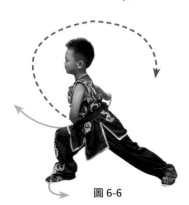

圖 6-6

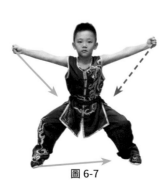

圖 6-7

圖 6-8

要求：左手及右手掛蓋時，兩臂伸直，左右轉動時轉腰坐髖身體立直。

Requirements: When the left hand and right hand are down-stroke crossed, straighten the arms, turn the waist when turning left and right, body upright when sitting on the hip.

幼兒長拳操

❖ 預備姿勢：並步站立 , 抱拳於腰間，目視前方（圖 1-0）。

Ready posture: Stand straight with folding stance, hold the fists to the sides of the waist, look forward (Fig .1-0).

❖ 兩手變掌 , 按於身體兩側，臂微曲，甩頭看左（圖 1-1）。

Change both hands to palms, press them to the sides of the body, slightly bend the arms, swing the head and look to the left (Fig .1-1).

❖ 預備姿勢（圖 1-2）。

Ready posture (Fig. 1-2).

❖ 按掌於身體兩側，臂微曲，甩頭看右（圖 1-3）。

Press the palms to the sides of the body, slightly bend the arms, swing the head and look to the right (Fig .1-3).

❖ 還原預備姿勢（圖 1-4）。

Revert to the ready posture (Fig .1-4).

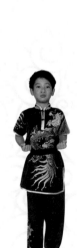

圖 1-0

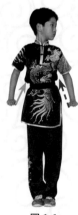

圖 1-1

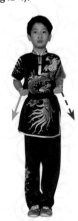

圖 1-2

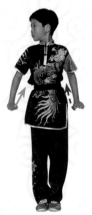

圖 1-3

圖 1-4

要求：雙手按掌，掌尖對準正前方，距離身體兩側各一拳遠，掌心平行於地面。

Requirements: Both hands with pressing palms, the fingertips of the palms face forward, in distance of one punch far from each side of the body, the center of palms parallel to the ground.

第二節 左右開立步推掌
Section 2 Left and right spread feet stance pushing palms

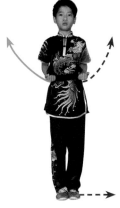

🌼 預備姿勢（圖 2-0）。

Ready posture (Fig .2-0).

🌼 兩手變掌，腕關節平行於肩向兩側推出，左腳向左側開立步，甩頭看左（圖 2-1）。

Change both hands to palms, push the palms to both sides with the wrist joints paralleled to the shoulder, left foot steps to the left to form a spread feet stance, swing the head and look to the left (Fig .2-1).

🌼 還原預備姿勢（圖 2-2）。

Revert to the ready posture (Fig .2-2).

圖 2-0

🌼 兩手變掌腕關節平行於肩向兩側推出，右腳向右側開立步，甩頭看右（圖 2-3）。

Change both hands to palms, push the palms to both sides with the wrist joints paralleled to the shoulder, right foot steps to the right to form a spread feet stance, swing the head and look to the right (Fig .2-3).

🌼 再還原預備姿勢（圖 2-4）。

Revert to the ready posture (Fig .2-4).

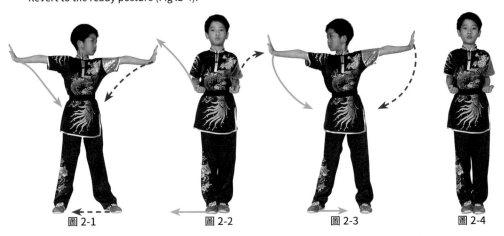

圖 2-1　　　　　圖 2-2　　　　　圖 2-3　　　　　圖 2-4

要求：開立步腳尖對準正前方，兩腳間距離于肩同寬。兩臂推平成直線，兩掌立直。

Requirements: The tiptoes should point to the front in the spread feet stance, the distance between two feet is the same as the width of the shoulder. Horizontally push the arms and from a straight line, erect and remain both palms standing straight.

幼兒長拳操

✿ 預備姿勢（圖 3-0）。

Ready posture (Fig .3-0).

✿ 兩手平拳向兩側衝出于肩平，左腳向左側開立步，甩頭看左（圖 3-1）。

Punch both flat fists to both sides with the wrist joints paralleled to the shoulder, left foot steps to the left to form a spread feet stance, swing the head and look to the left (Fig .3-1).

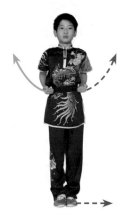

圖 3-0

✿ 兩手變掌，掌心向上向胸前砍出（圖 3-2）。

Change both hands to palms, the center of palms face up and chop them to the front of the chest (Fig .3-2).

✿ 兩手變勾向背後勾出，甩頭向左，勾尖向上（圖 3-3）。

Change both hands to hooks and hook them to the back, swing the head to the left, the tip of the hooks face up (Fig .3-3).

✿ 還原預備姿勢（圖 3-4）。

Revert to the ready posture (Fig .3-4).

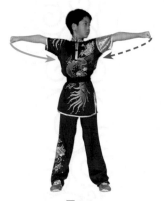
圖 3-1

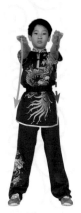
圖 3-2

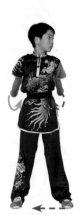
圖 3-3

圖 3-4

✿兩手拳向兩側衝出于肩平，右腳向右側開立步，甩頭
看右（圖 3-5）。

Punch both fists to both sides with the wrist joints paralleled
to the shoulder, right foot steps to the right to form a spread
feet stance, swing the head and look to the right (Fig .3-5).

圖 3-5

✿兩手變掌，掌心向上向胸前砍出（圖 3-6）。

Change both hands to palms, the center of palms face up and chop them to the front of the chest (Fig .3-6).

✿兩手變勾向背後勾出，甩頭向右，勾尖向上（圖 3-7）。

Change both hands to hooks and hook them to the back, swing the head to the right, the tip of the hooks
face up (Fig .3-7).

✿還原預備姿勢（圖 3-8）。

Revert to the ready posture (Fig .3-8).

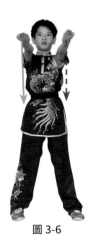 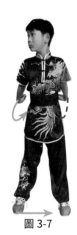

圖 3-6 　　　　　 圖 3-7 　　　　　 圖 3-8

要求：開立步腳尖對準正前方，兩腳間距離于肩同寬。頭要隨手左右甩出，目視前方。

Requirements: The tiptoes should point to the front in the spread feet stance, the distance between two feet
is the same as the width of the shoulder. Swing the head to the left and right followed with the hands, look
forward.

第四節 左右彈腿推掌
Section 4 Left and right flip leg pushing palm

❁ 預備姿勢（圖 4-0）。

Ready posture (Fig .4-0).

❁ 左腳向左側開立步，右手變掌向前推出（圖 4-1）。

Left foot steps to the left to form a spread feet stance, change the right hand to a palm and push it forward (Fig .4-1).

圖 4-0

❁ 換推左掌，同時右腿向前彈出（圖 4-2）。

Switch to push the left palm, at the same time flip the right leg forward (Fig .4-2).

❁ 收右腿推右掌（圖 4-3）。

Withdraw the right leg and push the right palm (Fig .4-3).

❁ 還原成預備姿勢（圖 4-4）。

Revert to the ready posture (Fig .4-4).

圖 4-1

圖 4-2

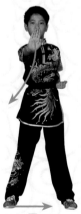
圖 4-3

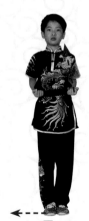
圖 4-4

✿ 右腳向右側開立步，左手變掌向前推出（圖 4-5）。

Right foot steps to the right to form a spread feet stance, change the left hand to a palm and push it forward (Fig .4-5).

✿ 換推右掌，同時左腿向前彈出（圖 4-6）。

Switch to push the right palm, at the same time flip the left leg forward (Fig. 4-6).

✿ 收左腿推左掌（圖 4-7）。

Withdraw the left leg and push the left palm (Fig .4-7).

✿ 還原成預備姿勢（圖 4-8）。

Revert to the ready posture (Fig .4-8).

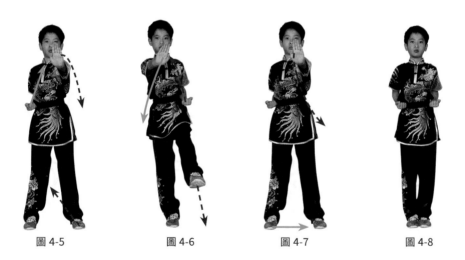

圖 4-5 圖 4-6 圖 4-7 圖 4-8

要求：開立步腳尖對準正前方，兩腳間距離于肩同寬。推掌時中指掌尖于鼻尖同高並在一條線上。彈腿時蹦腳尖，力達腳尖。

Requirements: The tiptoes should f point to the front in the spread feet stance, the distance between two feet is the same as the width of the shoulder. When pushing the palm, the tip of the middle finger is at the same height as the tip of the nose and they should be on the same line. Tightly straighten the tiptoes when flipping the leg, with the force reaches the tiptoes.

幼兒長拳操

第五節 左右弓步彈踢轉換
Section 5 Left and right changing in bow stance flip kicking

❁預備姿勢（圖 5-0）。

Ready posture (Fig .5-0).

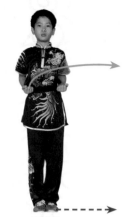

❁左腳向左側上步成左弓步拗衝拳（圖 5-1）。

Left foot steps on to the left to form a left bow stance punching fist (Fig .5-1).

❁彈右腿換衝左拳（圖 5-2）。

Flip the right leg and switch to punch the left fist (Fig .5-2).

圖 5-0

❁右腿退回成左弓步拗衝拳（圖 5-3）。

Withdraw the right leg to form a left bow stance punching fist (Fig .5-3).

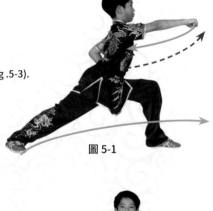

❁還原成預備姿勢（圖 5-4）。

Revert to the ready posture (Fig .5-4).

圖 5-1

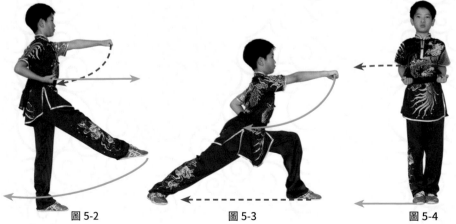

圖 5-2　　　　　　　圖 5-3　　　　　　　圖 5-4

❀ 右腳向右側上步成右弓步拗衝拳（圖 5-5）。

Right foot steps on to the right to form a right bow stance punching fist (Fig .5-5).

❀ 彈左腿換衝右拳（圖 5-6）。

Flip the left leg and switch to punch the right fist (Fig .5-2).

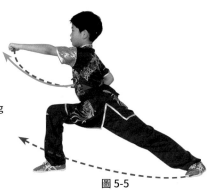

❀ 左腿退回成右弓步拗衝拳（圖 5-7）。

Withdraw the left leg to form a right bow stance punching fist (Fig .5-3).

❀ 還原成預備姿勢（圖 5-8）。

Revert to the ready posture (Fig .5-8).

圖 5-5

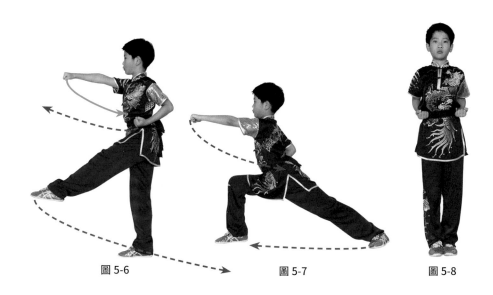

圖 5-6　　　　　圖 5-7　　　　　圖 5-8

要求：左右弓步成一線，衝拳时拳于肩同高。

Requirements: The left and right bow stance should to be in a line, and the fist is at the same height as the shoulder when punching.

第六節 弓馬步轉換分腳跳
Section 6 Changing in bow stance and horse stance parting foot jump

🏵 預備姿勢（圖 6-0）。

Ready posture (Fig .6-0).

🏵 雙腳左右跳分開成馬步，同時雙手左右分推掌，甩頭看左（圖 6-1）。

Separate both feet by jumping to the left and right and form a horse stance, at the same time, separate the palms by pushing them to the left and right, swing the head and look to the left (Fig .6-1).

🏵 還原成預備姿勢（圖 6-2）。

Revert to the ready posture (Fig .6-2).

🏵 再雙腳左右跳分開成馬步，同時雙手左右分推掌，甩頭看右（圖 6-3）。

Separate both feet by jumping to the left and right and form a horse stance, at the same time, separate the palms by pushing them to the left and right, swing the head and look to the right (Fig .6-3).

🏵 還原成預備姿勢（圖 6-4）。

Revert to the ready posture (Fig .6-4).

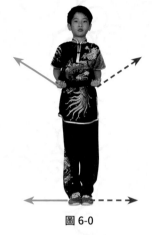

圖 6-0

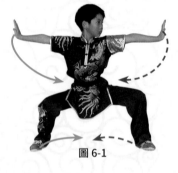

圖 6-1

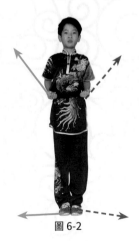

圖 6-2

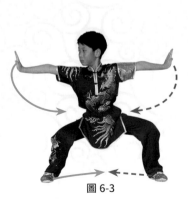

圖 6-3

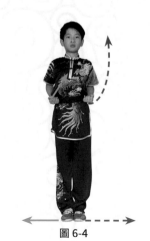

圖 6-4

✿ 雙腳左右跳分開成左弓步，同時雙手前後分推掌，甩頭
看右手（圖 6-5）。

Separate both feet by jumping to the left and right and form a
left bow stance, at the same time, separate and push the palms
by pushing them to the front and back, swing the head and look
to the right (Fig .6-5).

✿ 還原成預備姿勢（圖 6-6）。

Revert to the ready posture (Fig .6-6).

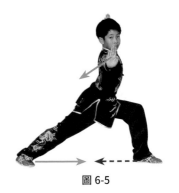

圖 6-5

✿ 再雙腳左右跳分開成右弓步，同時雙手前後分推掌，甩頭看左手（圖 6-7）。

Separate both feet by jumping to the left and right and form a right bow stance, at the same time, separate
and push the palms by pushing them to the front and back, swing the head and look to the left (Fig .6-7).

✿ 還原成預備姿勢（圖 6-8）。

Revert to the ready posture (Fig .6-8).

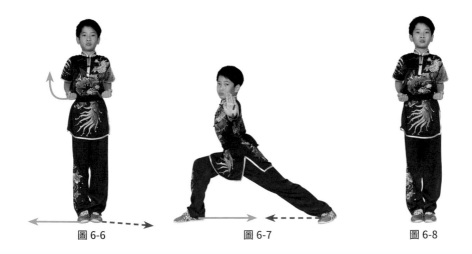

圖 6-6　　　　　　　　圖 6-7　　　　　　　　圖 6-8

要求：馬步左右分推掌兩臂要平。左右弓步推掌時，後面的手略高，掌尖可于頭頂平行。

Requirements: The arms in the horse stance with left and right separate pushing palms should be level. When
pushing the palms in the left and right bow stance, the hand at the back is slightly higher, the tip of the palm
can be parallel to the top of the head.

少兒功夫環

第一節 左右開立步擺環
Section 1 Left and right spread feet
stance swaying rings

❧ 預備式
Ready posture

❧ 兩腿併攏，身體直立，兩臂微屈持環垂於體側，頭正頸直，
目視前方（圖 1-0）。

Both legs stand side by side, straighten the body, slightly bend
both arms, hold and droop the rings to the sides of the body,
head up and neck straightened (Fig.1-0).

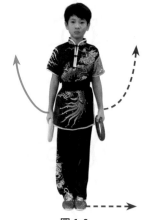

圖 1-0

要求：挺胸，收腹，立腰。

Requirements: Chest out, constrict belly, erect waist.

❧ 左開立步平舉環
Left spread feet stance horizontally lifting rings

❧ 左腳向左橫跨一步成開立步；兩手握環向兩側平舉，立
環手心朝前，目視前方（圖 1-1）。

Left foot takes a step to the left to form a spread feet stance;
hold the rings with both hands and horizontally lift them to both
sides, erect the rings and the center of hands face forward, look
forward (Fig.1-1).

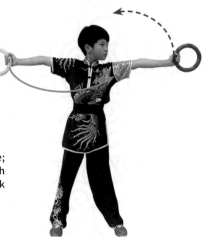

圖 1-1

要求：開立步兩腳相距略寬于肩，腳尖正直前方，兩臂平直。

Requirements: The distance between two feet should be slightly wider than the shoulder in the spread feet
stance, the tiptoes should point to the front, both arms should be level and straight.

✿ **開立步架亮環**

　　Spread feet stance blocking and flashing rings

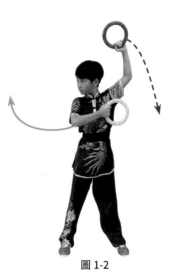

✿ 開立步不變，左手持環由側向上擺環至頭頂上方，立環
手心朝前，右手持環向左，屈肘平擺環至左胸前，立環
手心朝內，同時甩頭向右看（圖 1-2）

Remain the spread feet stance unchanged, left hand holds the
ring and sway it over the head from the side to the top, erect the
ring and the center of hand faces forward, right hand holds the
ring to the right, bend the elbow and horizontally sway the ring
to the front of the left chest, erect the ring and the center of hand
face inside, at the same time, swing the head and look to the left.
(Fig .1-2)

圖 1-2

要求：左手持環架於頭頂上方；右手持環屈肘環抱胸前；甩頭要快速有力。

Requirements: left hand holds the ring, and block it on top of the head; right hand holds the ring, bend and
encircle the elbow in front of the chest; swing the head fast and strong.

✿ **開立步平舉環**

　　**Spread feet stance horizontally
lifting rings**

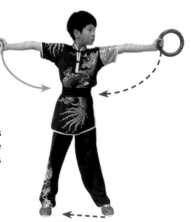

✿ 開立步不變，左手持環由上向左側擺至平舉；右手持環
向右擺至平舉；甩頭平視前方（圖 1-3）

Remain the spread feet stance unchanged, left hand holds
the ring and sway till it is horizontally lift from the top to the
right; right hand holds the ring and sway it to the right till it is
horizontally lift; swing the head and look forward (Fig .1-3).

圖 1-3

要求：兩手要同時擺環，兩臂要平直。

Requirements: Both hands should sway the rings at the same time, both arms should be level and straight.

少兒功夫環

✿ 并步還原
Revert to the folding stance

✿ 兩手持環向下收於體側，同時左腳收於右腳，并步直立，
目視前方（圖 1-4）

Hold the rings with both hands and withdraw them downward
to the sides of the body, at the same time withdraw the left foot
to the right foot, body upright with folding stance, look forward
(Fig.1-4).

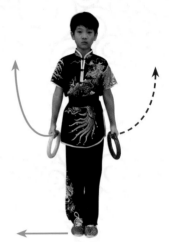

要求：同預備式

Requirements: Same as the ready posture

圖 1-4

✿ 右開立步平舉環
Right spread feet stance horizontally lifting rings

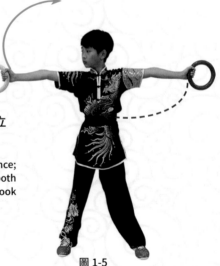

✿ 右腳向右橫跨一步成開立步；兩手握環向兩側平舉，立
環手心向前；目視前方（圖 1-5）

Right foot takes a step to the right to form a spread feet stance;
hold the rings with both hands and horizontally lift them to both
sides, erect the rings and the center of hands face forward, look
forward (Fig.1-5).

圖 1-5

要求：開立步，兩腳間距離略寬于肩，腳尖正直前方；兩臂要平直。

Requirements: The distance between two feet should be slightly wider than the shoulder in the spread feet
stance, the tiptoes should point to the front, both arms should be level and straight.

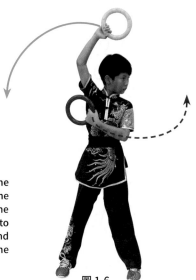

❀ 開立步架亮環
Spread feet stance blocking and flashing rings

❀ 開立步不變，右手持環由側向上擺環至頭頂上方，立環
手心朝前；左手持環向右，屈肘平擺環至右胸前，立環
手心朝內；同時甩頭向左看（圖 1-6）

Remain the spread feet stance unchanged, left hand holds the
ring and sway it over the head from the side to the top, erect the
ring and the center of hand faces forward, right hand holds the
ring to the left, bend the elbow and horizontally sway the ring to
the front of the left chest, erect the ring and the center of hand
face inside, at the same time, swing the head and look to the
right. (Fig .1-6)

圖 1-6

要求：左手持環架於頭頂上方；右手持環屈肘環抱于胸前，甩頭動作要快速有力。

Requirements: Left hand holds the ring, and block it on top of the head; right hand holds the ring, bend and
encircle the elbow in front of the chest; swing the head fast and strong.

❀ 開立步平舉環
Spread feet stance horizontally lifting rings

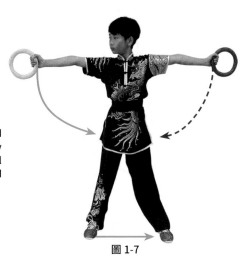

❀ 開立步不變，右手持環向右側擺至平舉；左手持
環向左擺至平舉；甩頭平視前方（圖 1-7）

Remain the spread feet stance unchanged, left hand
holds the ring and sway it to the left till it is horizontally
lift; right hand holds the ring and sway it to the right till
it is horizontally lift; swing the head and look forward
(Fig .1-7).

圖 1-7

要求：兩手同時擺環，兩臂平直。

Requirements: Both hands should sway the rings at the same time, both arms should be level and straight.

✿ 并步還原
Revert to the folding stance

✿ 兩手持環向下收於體側，同時右腳收於左腳，并步直立，
目視前方（圖 1-8）

Hold the rings with both hands and withdraw them downward
to the sides of the body, at the same time withdraw the right foot
to the left foot, body upright with folding stance, look forward
(Fig.1-8)

要求：同預備式

圖 1-8

Requirements: Same as the ready posture

第二節 左右蹬腳推環
Section 2 Left and right heel
kicking pushing ring

✿ 左弓步推環
Left bow stance pushing ring

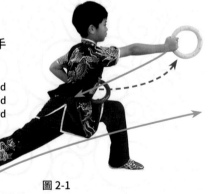

✿ 左腳向左側邁出一步成左弓步，左手持環收於腰側，右手
持環立環向前推出，目視前方（圖 2-1）

Left foot steps to the left and form a left bow stance, left hand
holds the ring and withdraw it to the side of the waist, right hand
holds the ring, erect and push the ring forward, look forward
(Fig.2-1).

圖 2-1

要求：弓步後腿挺膝，後腳要全腳著地；推環要有力。

Requirements: Straighten the knee of the rear leg in bow stance, the rear foot should be flat on the ground;
push the ring forcefully.

右蹬腿推環
Right kicking leg pushing ring

左腿微屈，支撐身體重心，右腿隨即屈膝提起，勾腳尖向前蹬出；同時左手持環向前推出，同時右手持環收於腰間，目視前方（圖 2-2）

Slightly bend the left leg, support the center of gravity, immediately bend and lift the right knee, cock the tiptoes and kick it forward; at the same time, left hand holds the ring and push it forward, at the same time, right hand holds the ring and withdraw it to the side of the waist, look forward (Fig.2-2).

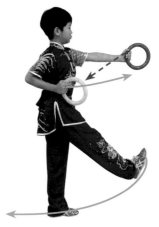

圖 2-2

要求：蹬腿由屈到伸，力達腳跟，身體直立，不可歪斜。

Requirements: Kick the leg from bent to extended, the force reaches the heel, body upright, do not skew.

左弓步推環
Left bow stance pushing ring

右腿回落成左弓步，左手持環收於腰間；右手持環向前立環推出，目視前方（圖 2-3）

Withdraw and drop the right leg to form a left bow stance, left hand holds the ring and withdraw it to the side of the waist, right hand holds the ring, erect and push the ring forward, look forward (Fig.2-3).

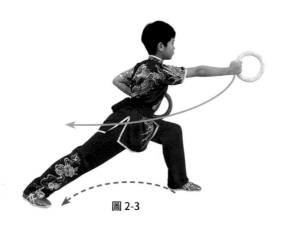

圖 2-3

少兒功夫環

❀ **并步還原**
Revert to the folding stance

❀ 身體右轉左腳收回，兩腿併攏成并步；同時兩手持環收
於大腿兩側；目視前方（圖 2-4）。

Turn right and withdraw the left foot, both legs stand side by side
to form a folding stance; at the same time, both hands hold the
rings and withdraw them to the sides of the thighs; look forward
(Fig.2-4).

圖 2-4

要求：轉身回收需協調一致。

Requirements: The movements of turn the body and withdrawing the foot need to be coordinated.

❀ 第二個 4 拍動作相同方向相反。（圖 2-5-8）

Same movements but opposite direction in the second 4 beats. (Fig.2-5-8)

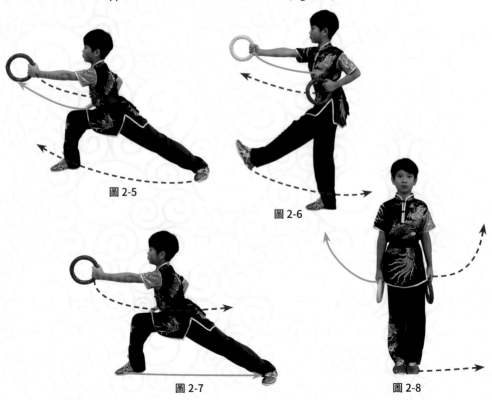

圖 2-5

圖 2-6

圖 2-7

圖 2-8

第三節 左右歇步擺環
Section 3 Left and right rest stance swaying rings

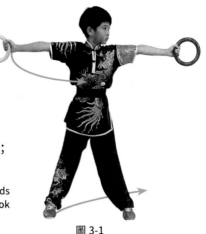

圖 3-1

❁ **開立步平舉環**

Spread feet stance horizontally lifting rings

❁ 左腳向左橫跨一步成開立步；兩手持環立環向兩側平舉；
目視前方（圖3-1）。

Left foot steps to the left to form a spread feet stance; both hands hold and erect the rings, horizontally lift them to both sides; look forward (Fig.3-1).

要求：同前開立步平舉環

Requirements: Same as the previous spread feet stance horizontally lifting rings

❁ **歇步平擺環**

Rest stance horizontally swaying rings

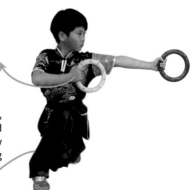

圖 3-2

❁ 右腳向左腳斜後方插步，兩腿屈膝全蹲成歇步，右手持
環向左屈肘平擺至左胸前，持環手手心朝內，甩頭向左
平視（圖3-2）

Right foot takes a diagonal backward crossover step to the left, bend both knees and squat to form a rest stance, right hand holds the ring to the left, bend the elbow and horizontally sway the ring to the front of the left chest, the hand holding the ring faces inside, swing the head and look to the left (Fig.3-2).

要求：歇步兩腿自然交叉，屈膝全蹲，後腿前腳掌著地，腳跟提起，臀部坐於小腿上，挺胸直腰。

Requirements: Naturally cross the legs in the rest stance, bend the knees and squat fully, the forefoot of the rear leg should be flat on the ground, lift the heel, with the hip sitting on the calf, chest out and straighten the waist.

少兒功夫環

✿ 開立步平擺環
Spread feet stance horizontally swaying rings

✿ 身體立起，右腳向右橫跨一步成開立步；右手持環向右直臂平擺；頭向右轉；目視前方（圖 3-3）

Body upright, right foot steps to the right to form a spread feet stance, right hand holds the ring and sway it to the right straightly; turn the head to the right; look forward (Fig.3-3).

要求：橫跨步與擺臂甩頭同時進行。

Requirements: The horizontal step, swaying arm, and swinging head should be done at the same time.

✿ 并步還原
Revert to the folding stance

✿ 身體直立，左腳收於右腳，兩腿併攏，同時兩手持環收於兩腿側。目視正前方（圖 3-4）

Body upright, withdraw the left foot to the right foot, both legs stand side by side, at the same time, both hands hold the rings and withdraw them to the sides of the thighs; look forward (Fig.3-4).

要求：同前并步勢

Requirements: Same as the previous folding stance

✿ 第二個 4 拍，動作相同方向相反 （圖 3-5-8）

Same movements but opposite direction in the second 4 beats. (Fig.3-5-8)

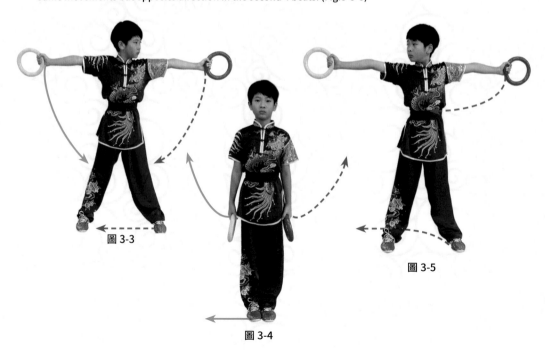

圖 3-3

圖 3-4

圖 3-5

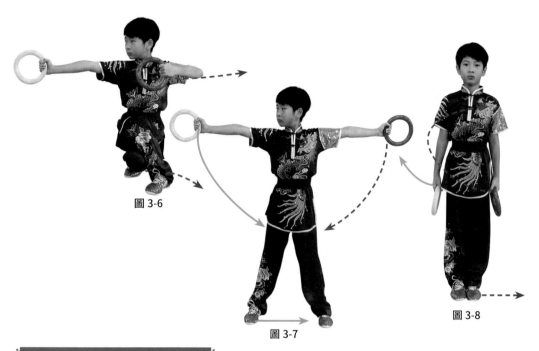

圖 3-6

圖 3-7

圖 3-8

<div style="background-color:gray">

第四節 左右弓步開環
Section 4 Left and right bow step opening rings

</div>

❀ **左弓步開環**
Left bow step opening ring

❀ 左腳向左側邁出一步成左弓步，身體面對前方；兩手持
環向左側平擺至肩同高，立環右手心朝外，左手心朝內，
然後左手屈肘回拉至左胸前；目視左前方（圖 4-1）。

Left foot steps to the left to form a left bow stance, the body faces
forward; both hands hold the rings and sway them to the left till
they are level with the shoulder, erect the rings, the center of
right hand faces outside, the center of left hand faces inside, then
bend the left elbow and withdraw it to the front of the left chest;
look to the front left (Fig. 4-1).

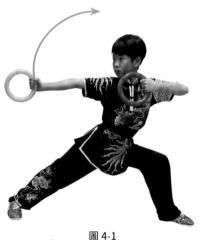

圖 4-1

要求：整個動作要連貫一氣呵成，成拉弓勢。

Requirements: The whole movements should be coherent and done in one go, form a pulling bow stance.

少兒功夫環

✿ 左弓步架亮環
Left bow stance blocking and flashing rings

✿ 弓步和左持環手不變；上身稍左轉，右手持環向上擺環
至頭頂上方，右手心朝上；甩頭目視左前方（圖4-2）。

Remain the bow stance and the left hand holding the ring
unchanged; slightly turn rhe upper body to the left, right hand
holds the ring and sway it upward till the top of the head, the
center of the right hand faces upward; swing the head and look
to the front left (Fig.4-2).

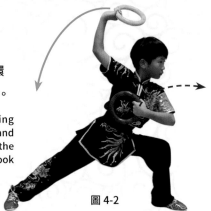

圖 4-2

要求：架亮環與甩頭同時進行。

Requirements: Blocking and flashing rings, and swinging the head should be done at the same time.

✿ 弓步平舉環
Bow stance horizontally lifting rings

✿ 弓步不變，左手持環向左擺平；右手持環由頭
頂上方向下平擺；兩臂成水平；目視前方不變
（圖4-3）

Remain the bow stance unchanged, left hand holds
the ring and horizontally sway it to the left; right
hand holds the ring and horizontally sway it from the
top of the head to the bottom; both arms are level;
continue looking forward (Fig.4-3).

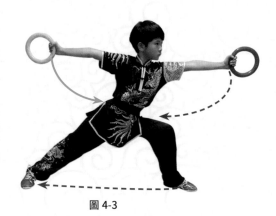

圖 4-3

要求：兩臂擺動同時進行，兩臂平直。

Requirements: Sway both arms at the same time, both arms should be level and straightened.

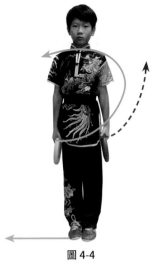

✿ 并步還原
Revert to the folding stance

✿ 左腳并右腳站起，兩手持環向下收至大腿兩側還原，頭
向左轉（圖 4-4）

Stand upright, both hands hold the rings and withdraw them
downward to the sides of the thighs to revert the movements,
turn the head to the left (Fig.4-4).

要求：抬頭，挺胸，收腹，立腰。
Requirements: Head up, chest out, construct belly, erect waist.

✿ 第二個 4 拍動作相同方向相反。（圖 4-5-8）

Same movements but opposite direction in the second 4 beats.
(Fig.4-5-8)

圖 4-4

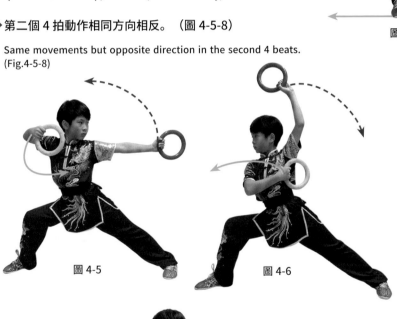

圖 4-5

圖 4-6

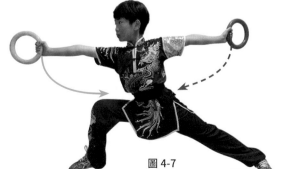

圖 4-7

圖 4-8

少兒功夫環

第五節 開立步交叉繞環
Section 5 Jumping and cross revolving rings

❧ **左開立步交叉環**
Jumping spread feet stance with crossed rings

❧ 左腳向左側開立步；兩手持環由身體兩側向體前交叉環
抱，左手在內右手在外；兩手心朝內，目視前方（圖 5-1）

Feet off to both sides to form a spread feet stance; both hands hold the rings and cross encircle from the sides of the body, with the left hand inside and right hand outside; the center of both hands face inside, look forward (Fig.5-1).

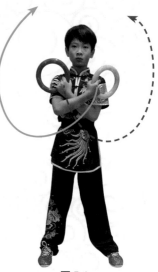

圖 5-1

要求：開立步與兩手交叉環抱同時進行。

Requirements: The jumping spread feet stance and the encircle with hands crossed should be done at the same time.

❧ **開立步頭上繞環**
Jumping spread feet stance revolving rings above the head

❧ 開立步不變；同時兩手持環下落經兩側繞環至頭頂上方，
兩持環手心朝前，目視前上方（圖 5-2）

Feet off and feet down in the spread feet stance; at the same time both hands hold and drop the ring, and revolve the rings to the top of the head through both sides, the center of hands holding rings face forward, look to the upper front (Fig.5-2).

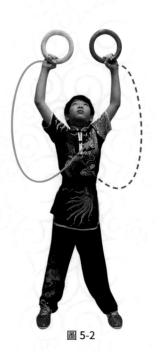

圖 5-2

要求：兩手持環繞環要成立圓。

Requirements: Both hands should form an erecting cirlcle when revolving with the rings.

❁ 開立步交叉環
Jumping spread feet stance crossed rings

❁ 開立步不變；兩手持環園由上向下經兩側向前交叉環抱于胸前，左手在內右手在外；目視前方（圖 5-3）

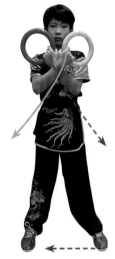

Feet off to both sides to form a spread feet stance; both hands hold the rings and encircle them with a cross in front of the chest through both sides from the top to the bottom, with the left hand inside and right hand outside; look forward (Fig.5-3).

要求：同前

Requirements: Same as the previous movement.

圖 5-3

❁ 并步還原
Revert to the folding stance

❁ 左腿直立并步，兩手持環下落於身體兩側還原，目視前方（圖 5-4）

Feet off and feet down, both hands hold and drop the rings to the sides of the body to revert the movements, look forward (Fig.5-4).

要求：整個動作要連貫協調，一氣呵成。

Requirements: The whole movement should be coherent and done in one go.

❁ 第二個 4 拍同前。

Same movements but opposite direction in the second 4 beats.

圖 5-4

少兒功夫扇

✿ 預備式
Ready posture

✿ 兩腿併攏，身體直立，兩臂微屈持扇垂於體前，頭正頸直，目視前方（圖 1-0）。

Both legs stand side by side, straighten the body, slightly bend both arms, hold and droop the fan to the sides of the body, head up and neck straightened, look forward (Fig.1-0).

要求：挺胸，收腹，立腰。

Requirements: Chest out, constrict belly, erect waist.

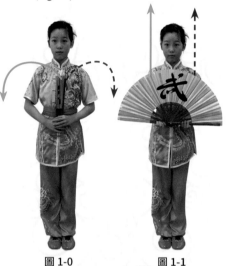

第一節 并步上下舉扇
Section 1 Folding stance up and down lifting fan

✿ 并步開扇
Folding stance opening fan

✿ 身體直立；兩臂屈肘腹前抱扇，兩手抓住扇股向兩側開扇；目視前方（圖 1-1）。

Body upright, bend both elbows and hold the fan in front of the belly, hold the bottom of the fan with both hands and open it to both sides; look forward (Fig.1-1).

要求：扇股指扇的兩側較厚的地方。

Requirements: The bottom of the fan means the thicker area on both sides of the fan.

圖 1-0 圖 1-1

✿ 并步開扇上舉
Folding stance opening and lifting fan

✿ 身體直立不變；兩手開扇上舉；目視前方（圖 1-2）。

Remain the body upright unchanged; open the fan with both hands and lift it; look forward (Fig .1-2).

要求：上舉扇兩臂伸直。

Requirements: Straighten both arms when lifting the fan.

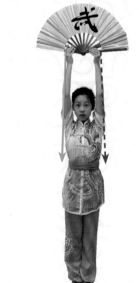

圖 1-2

✿ 并步開扇下落
Folding stance opening and dropping fan

✿ 身體直立不變；兩手開扇下落至腹前；目視前方（圖 1-3）。

Remain the body upright unchanged; open the fan with both hands and drop it in front of the belly; look forward (Fig.1-3).

要求：腹前抱扇，兩臂微屈，環抱於腹前。

Requirements: Hold the fan in front of the belly, slightly bend both arms, encircle it in front of the belly.

✿ 并步合扇
Folding stance closing fan

圖 1-3

✿ 身體直立不變；兩手抓握扇股合攏，成腹前抱扇；目視前方（圖 1-4）。

Remain the body upright unchanged; hold the bottom of the fan with both hands to close it, hold the fan in front of the belly; look forward (Fig.1-4).

要求：合扇後成立扇環抱於腹前。

Requirements: Erect and encircle the fan in front of the belly after closing the fan

注意：5-8 拍同前 4 拍

Note: 5-8 beats are the same as the previous 4 beats

圖 1-4

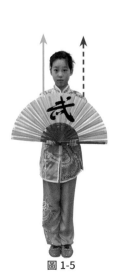

圖 1-5

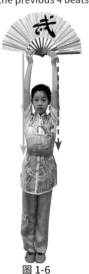

圖 1-6

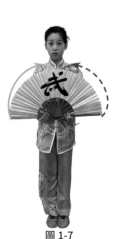

圖 1-7

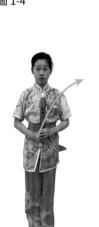

圖 1-8

少兒功夫扇

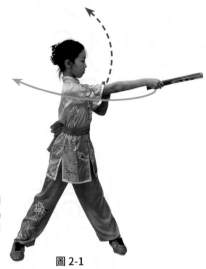

左開立步刺扇
Left spread feet stance stabbing fan

左腳向左側方邁出一步成左開立步；右手握扇向前平刺，左手劍指附在右臂上；目視前方（圖 2-1）。

Left foot steps to the left to form a spread feet stance; right hand holds the fan and horizontally stab it forward, left hand forms a sword finger and is attached to the right forearm; look forward (Fig.2-1).

圖 2-1

要求：弓步前腿屈膝半蹲，大腿接近水平，膝蓋約垂直腳尖或腳背，後腿挺膝伸直，腳尖內扣，兩腳全腳著地。右手刺扇需平直。

Requirements: Bend the knee of the foreleg and semi-squat in the bow stance, the thigh should be close to the level, the knee should be approximately perpendicular to the tiptoes or the instep, straighten the rear leg and the knee, buckle the tiptoes, both feet should be flat on the ground. Horizontally and straightly stab the fan with the right hand.

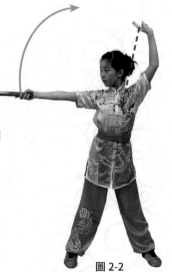

開立步平斬扇
Spread feet stance horizontally cutting fan

身體右轉，兩腳尖正直前方成開立步；右手持扇手心向上平斬至右體側；左手劍指架於頭頂上方；目視右前方（圖 2-2）。

Upright the body and turn right, the tiptoes of both feet point to the front to form a spread feet stance; right hand holds the fan with the center of hand facing down, horizontally cut it to the right; left hand forms a sword finger and block it above the head; look to the front right (Fig.2-2).

圖 2-2

要求：轉身時注意不可前俯后仰；右手持扇直臂弧形向右平擺；甩頭向右前方看。

Requirements: Pay attention to the tiptoes turning when turning the body; right hand holds the fan, straightly arc it to the right and place it horizontally; swing the head and look to the front right.

✿ 開立步挑扇
Spread feet stance snapping palm

✿ 開立步不變，右手持扇向上直臂挑起；同時左手劍指向前直臂下落與肩平，指尖向前，手心向下；目視前方（圖2-3）。

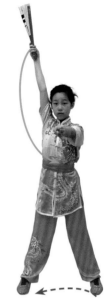

Remain the spread feet stance unchanged, right hand holds the fan and straightly snap it upward; at the same time, straightly drop the left hand with sword finger forward to the shoulder level, the fingertips point to the front, the center of hand faces down; look forward (Fig.2-3).

圖 2-3

要求：挑扇上舉，臂盡量貼於右耳，劍指食指中指伸直併攏，無名指和小拇指屈於掌心，大拇指壓於無名指小拇指第一指節上。

Requirements: Snapping the fan and lift it, place the arm near the right ear as much as possible, the index finger and the middle finger of the sword finger should be straightened and closely together, bend the ring finger and the little finger on the center of palm, press the thumb on the first knuckle of the ring finger and the little finger.

✿ 并步抱扇
Folding stance holding fan

✿ 左腳收於右腳內，兩腿併攏直立；兩手收抱於腹前成抱扇；目視前方（圖 2-4）。

Withdraw the left foot to the right foot, both legs stand side by side and stand upright; withdraw both hands in front of the belly to hold the fan; look forward (Fig.2-4).

圖 2-4

要求：同前并步勢；兩手抱扇要協調一致。

Requirements: Same as the previous folding stance, holding the fan with both hands should be coordinated.

少兒功夫扇

注意：5-8 拍同前 4 拍

Note: 5-8 beats are the same as the previous 4 beats

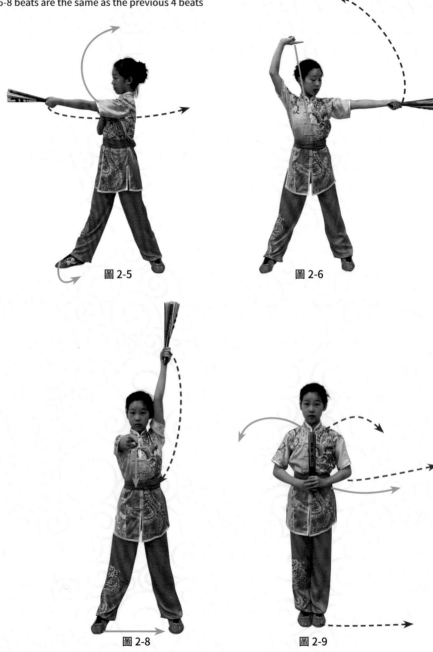

圖 2-5

圖 2-6

圖 2-8

圖 2-9

第三節 左右弓步開扇
Section 3 Left and right bow stance opening fan

✿ 左弓步開扇
Left bow stance opening fan

✿ 左腳向左側方邁出一步成左弓步；兩手握扇
股，隨弓步向兩側將扇打開，立於左前方；目
視正前方（圖 3-1）。

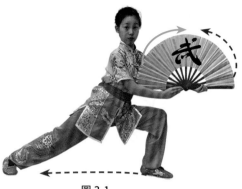

Left foot steps to the left to form a left bow stance; hold the bottom of the fan with both hands, open the fan to both sides when forming the bow stance, erect the fan to the front left; look forward (Fig.3-1).

圖 3-1

要求：開扇與弓步同時完成。

Requirements: Open the fan and form the bow stance at the same time

✿ 并步合扇
Folding stance closing fan

✿ 左腳收於右腳內側，兩腿併攏伸直；兩手合
扇收於體前；目視正前方（圖 3-2）。

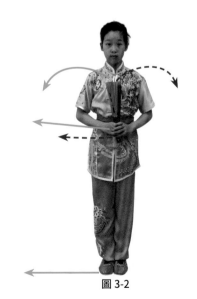

Withdraw the left foot to the inside of the right foot, both legs stand side by side and stand upright; close the fan with both hands and withdraw it in front of the body; look forward (Fig.3-2).

圖 3-2

要求：兩手抱扇於體前，右手握扇，左手附於右手上。

Requirements: Hold the fan with both hands in front of the body, right hand holds the fan, left hand is attached to the right hand.

少兒功夫扇

❀ 右弓步開扇
Right bow stance opening fan

❀ 右腳向右側方邁出一步成右弓步；兩手握扇隨弓步向兩側將扇打開，立於右前方，目視正前方（圖 3-3）。

Right foot steps to the right to form a right bow stance; hold the fan with both hands and open it to both sides when forming the bow stance, erect the fan to the front right, look forward (Fig.3-3).

要求：同前
Requirements: Same as the previous movements

❀ 并步收扇
Folding stance closing fan

❀ 右腳收於左腳內側，兩腿併攏直立；兩手合扇收於體前；目視正前方（圖 3-4）。

Withdraw the right foot to the inside of the left foot, both legs stand side by side and stand upright; close the fan with both hands and withdraw it in front of the body; look forward (Fig.3-4).

要求：同前
Requirements: Same as the previous movements

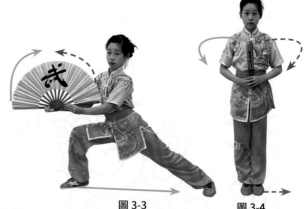

圖 3-3 圖 3-4

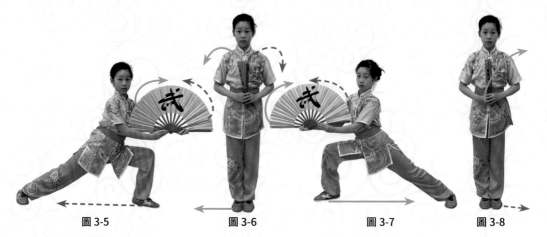

圖 3-5 圖 3-6 圖 3-7 圖 3-8

注意：5-8 拍同前 4 拍
Note: 5-8 beats are the same as the previous 4 beats

第四節 左右蹬腳刺扇
Section 4 Left and right heel kicking stabbing fan

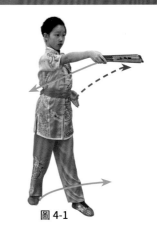

❀ **左上步刺扇**
 Left advancing step pushing fan

❀ 身體左轉 45 度，左腳向左前方邁出一步；右手握扇向前平刺；
 左手變掌收於左腰間，目視左前方（圖 4-1）。

 Turn left 45 degrees, right foot steps to the front left, erect and push the
 fan forward; change the left hand to a palm and withdraw it to the left
 waist, look to the front left (Fig.4-1).

圖 4-1

 要求：刺扇時重心落於兩腿中，扇于臂平直。

 Requirements: The center of gravity falls on both legs when pushing the fan

❀ **蹬腿推掌**
 Heel kicking pushing palm

❀ 身體重心移至左腳，右腳屈膝提起，勾腳尖向前蹬出；右手持
 扇收於右腰間，同時，左掌立掌向前推出；目視左前方（圖 4-2）。

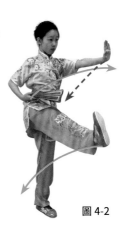

 Move the center of gravity to the left foot, bend and lift the right knee,
 cock the tiptoes and kick it forward; tight hand holds the fan and
 withdraw it to the right of the waist, at the same time, erect and push
 the left palm forward; look to the front left (Fig.4-2).

圖 4-2

 要求：蹬腿要直，力達腳跟，支撐腿可稍屈。

 Requirements: The kicking foot should be straightened, with the force reaches the heel, the supporting
 leg can be slightly bent.

❀ **後落步刺扇**
 Backward dropping step pushing fan

❀ 右腿回落至左腳斜後方，右手持扇隨落腿向前刺出，左掌收於
 左腰間，掌心向上，目視前方（圖 4-3）。

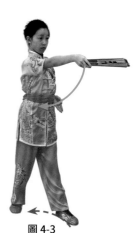

 Withdraw and drop the right foot diagonally behind the left foot, right
 hand holds the fan, erect and push the fan forward when dropping the
 leg, withdraw the left palm to the left of the waist, the center of palm
 faces up, look forward. (Fig.4-3).

 要求：同前（圖 4-1）

 Requirements: Same as the previous movements (Fig.4-1).

圖 4-3

少兒功夫扇

✿ 并步收扇
Folding stance closing fan

✿ 身體轉正，左腳收於右腳內側，兩腿併攏直立，兩手收於體前；目視正前方（圖4-4）。

Turn to the front, withdraw the left foot to the inside of the right foot, both legs stand side by side and stand upright, withdraw both hands in front of the body; look forward (Fig.4-4).

要求：同前
Requirements: Same as the previous movements

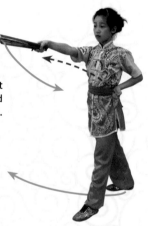

圖 4-4

✿ 右上步刺扇
Right bow stance opening fan

✿ 身體右轉45度，左腳向右前方邁出一步；右手握扇向前平刺，左手變掌收於左腰間，目視右前方（圖4-5）。

Turn right 45 degrees, left foot steps to the front right, erect and push the fan forward; change the left hand to a palm and withdraw it to the left waist, look to the front right (Fig.4-5).

要求：同前
Requirements: Same as the previous movements

圖 4-5

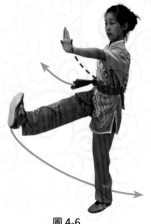

✿ 蹬腿推掌
Folding stance closing fan

✿ 身體重心移至左腳，右腳屈膝提起，勾腳尖向前蹬出；右手持扇收於右腰间，同時左掌立掌向前推出，目視前方（圖4-6）。

Move the center of gravity to the left foot, bend and lift the right knee, cock the tiptoes and kick it forward; right hand holds the fan and withdraw it to the right of the waist, at the same time, erect and push the left palm forward; look forward left (Fig.4-6).

要求：同前
Requirements: Same as the previous movements

圖 4-6

✿ 後落步刺扇
Folding stance closing fan

✿ 右腿回落至左脚斜後方，右手持扇随落腿向前刺出，左掌收於左腰间，掌心向上，目视前方 (图 4-7)。

Withdraw and drop the right foot diagonally behind the left foot, right hand holds the fan, erect and push the fan forward when dropping the leg, withdraw the left palm to the left of the waist, the center of palm faces up, look forward. (Fig.4-7).

要求：同前

Requirements: Same as the previous movements

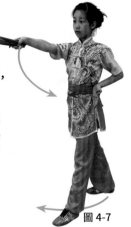

圖 4-7

✿ 并步收扇
Folding stance closing fan

✿ 身體轉正，右腳收於左腳內側，兩腿併攏直立，兩手收於體前，目視正前方 (图 4-8)。

Turn to the front, withdraw the right foot to the inside of the left foot, both legs stand side by side and stand upright, withdraw both hands in front of the body; look forward (Fig.4-8).

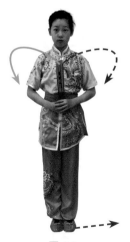

圖 4-8

少兒功夫扇

第五節 左右歇步開扇
Section 5 Left and right rest stance opening fan

❀ 開立步開扇

Spread feet stance opening fan

❀ 左腳向左側橫跨一步成開立步；同時兩手握扇柄向兩側開扇成體前抱扇；目視前方（圖 5-1）。

Left foot steps to the left to form a spread feet stance; at the same time, hold the bottom of the fan with both hands and open the fan to both sides, hold the fan in front of the body; look forward (Fig.5-1).

要求：抱扇，上抬不要擋眼睛

Requirements: Do not block the eyes when holding the fan

❀ 歇步擺扇

Rest stance swaying fan

❀ 右腳向左腳斜後方插步，腳跟提起，前腳掌著地，兩腿屈膝全蹲，臀部坐於右小腿上，靠近腳跟，同時隨屈蹲兩手開扇向右擺至右前側；目視正前方（圖 5-2）。

Right foot takes a diagonal backward crossover step to the left, lift the heel, the forefoot should be flat on the ground, bend both knees and squat fully, with the hip sitting on the calf and close to the heel, at the same time open the fan with both hands when bending and squatting, sway the fan to the right and place it to the front right; look forward (Fig.5-2).

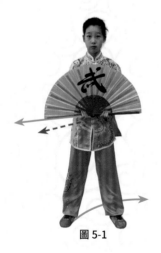

圖 5-1

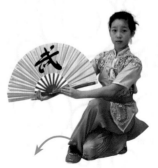

圖 5-2

❀ 開立步抱扇
Spread feet stance holding fan

❀身體直立，右腳向右側橫跨一步成開立步；兩手持扇開扇收於體前抱扇；目視前方（圖 5-3）。

Body upright, right foot steps to the right to form a spread feet stance; open the fan with both hands, withdraw it in front of the body to hold the fan; look forward (Fig.5-3).

要求：同 5-1 圖
Requirements: Same as fig.5-1.

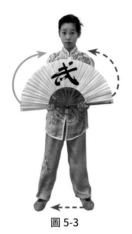

圖 5-3

❀ 并步收扇
Folding stance closing fan

❀左腳收於右腳內側，兩腿併攏直立；兩手收於體前；目視正前方（圖 5-4）。

Withdraw the left foot to the inside of the right foot, both legs stand side by side and stand upright; withdraw both hands in front of the body; look forward (Fig.5-4).

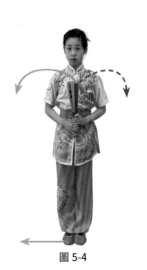

圖 5-4

少兒功夫扇

要求：同前
Requirements: Same as the previous movements

注意：5-8 拍同前 4 拍
Note: 5-8 beats are the same as the previous 4 beats

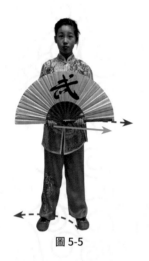

圖 5-5

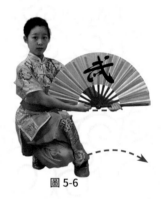

圖 5-6

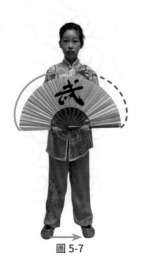

圖 5-7

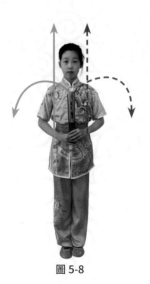

圖 5-8

第六節 跳馬步開扇
Section 6 Jumping horse stance opening fan

✿ **并步上舉開扇**
 Spread feet stance lifting and opening fan

✿ 身體直立不變，兩手持扇上舉，兩手握住扇股兩側，向外開扇；目視上方（圖 6-1）。

 Remain the body upright unchanged, hold the fan with both hands and lift it, hold both sides of the fan with both hands, open the fan outward; look up. (Fig.6-1).

 要求：挺胸，立腰。
 Requirements: chest out, erect waist.

✿ **體前抱扇**
 Holding fan in front of the body

✿ 身體直立不變，兩手持扇合扇下落至腹前抱扇；目視前方（圖 6-2）。

 Remain the body upright unchanged, hold the fan with both hands, close the fan and drop it in front of the belly to hold the fan; look forward (Fig.6-2).

 要求：同前
 Requirements: Same as the previous movements

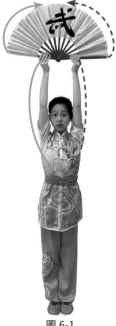

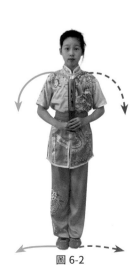

圖 6-1　　　　　　　圖 6-2

少兒功夫扇

🔹 跳馬步開扇
Jumping horse stance opening fan

🔹 跳起分腿下落成馬步；同時兩手抓握扇股向兩側開扇；目視前方（圖 6-3）。

Jump and separate both legs, drop to form a horse stance; at the same time hold the bottom of the fan with both hands to open the fan to both sides; look forward (Fig.6-3).

要求：馬步間距本人的三腳半寬，屈膝下蹲，大腿接近水平，膝關節約垂直于腳尖，兩腳正直前方。

Requirements: The feet in horse stance is about three and a half feet in distance, bend the knees and squat, the thighs are close to the level, the knee is approximately perpendicular to the tiptoes, both feet face forward.

🔹 并步合扇
Folding stance closing fan

🔹 跳起兩腿併攏直立，同時兩手合扇收於腹前；目視前方（圖 6-4）。

Jump and both legs stand side by side and stand upright, at the same time cloe the fan with both hands and withdraw it in front of the belly; look forward (Fig.6-4).

要求：同前

Requirements: Same as the previous movements

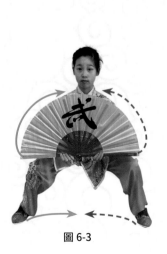

圖 6-3

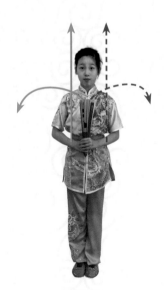

圖 6-4

注意：5-8 拍同前 4 拍

Note: 5-8 beats are the same as the previous 4 beats

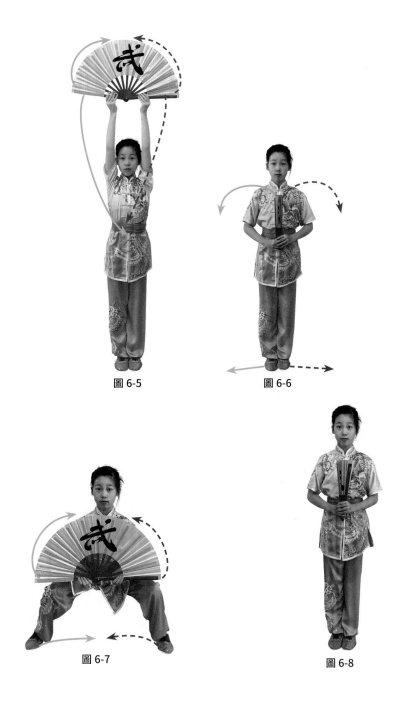

圖 6-5

圖 6-6

圖 6-7

圖 6-8

少兒小南拳

預備式
Ready posture

❀ 兩手變拳，兩手屈肘收抱腰間，拳心向上；目視前方（圖1）.

Change both hands to fists, bend the elbows and withdraw them besides the waist, center of fists face up; look forward (Fig. 1).

要求：抬頭，挺胸，收腹，立腰。

Requirements: head up, chest out, constrict the belly, erect the waist.

❀ **起勢**
Starting form

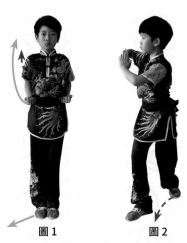

圖1　圖2

❀ 右腳向前上步，腳尖外展。兩腿屈膝，左腳跟略抬，兩臂向外，向裡，向右擺。右拳置於右胸前，拳心向下，拳面朝左。左掌置右拳面前，掌心朝右，手指朝上。目視右側方（圖2）。

Right foot steps forward, with tiptoes outstretched. Bend knees, slightly lift the left heel, swing both arms outwards, then inwards, and move to the right. Right palm change to fist, and place it in front of the right chest, with the center of the fist facing down and the face of the fist facing left. Place the left palm in front of the right fist, with fingers facing upwards. Look to the right (Fig. 2).

要求：右腳上步，全腳著地，身體稍右移，重心偏於右腿；兩臂擺向右前方時應迅速屈肘。

Requirements: Right foot steps forward, with the whole foot standing on the ground. Slightly move the body to the right, with the center of gravity on the right foot. Bend your elbow quickly when swinging both arms to the right.

❀ 左腳上步，前腳掌虛點地面，成虛步，身體稍左轉，右拳隨轉身向前平衝，高於肩平，拳面朝前，拳心朝下。左掌向前推出，高于肩平，掌心朝前，掌指朝上。目視前方（圖3）。

Left foot steps forward, touching the ground with the forefoot, forming an empty step. Slightly turn left, right fist, level with the shoulder, the face of the fist facing forward, the center of the fist facing down. Push the left palm forward, level with the shoulder, center of the palm facing forward, palm fingers facing upwards. Look forward (Fig. 3).

要求：虛步，一腿屈膝，身體重心落於此腿。另一腿屈膝，前腳掌著地。上體盡量挺直，不可前俯。

Requirements: Empty step, bend one leg with the center of gravity. Bend the other leg, with the forefoot touching the ground. The upper body should be as straight as possible, do not lean forward.

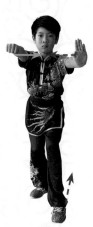

圖3

✿ 左腳向後撤步，腳跟抬起，左掌變拳，兩拳屈肘回拉於胸前，兩拳相對，拳心朝下。目視前方（圖 4）。

Left foot steps backward, lift the heel, left palm change to fist, bend both elbows and pull the fists to the chest, both fists facing each other, and the center of fists facing down. Look forward (Fig. 4).

要求：兩臂回拉于左腳撤步需同時進行，兩臂要平，兩拳間有一拳間距離。

Requirements: Pull the arms back and step the left foot backward at the same time. Both arms should be level and there is a distance of about one fist between both fists.

✿ 右腳後退于左腳並步，兩腿併攏伸直；同時兩肘尖向前夾，至前方向下向後，兩拳收抱於腰兩側，拳心向上。目視前方（圖 5）。

Right foot steps backward with both feet standing side by side, at the same time both elbows clamp forward, then downwards and to the back, place the fists on both sides of the waist, with the center of fists facing upwards. Look forward (Fig. 5).

要求：兩肘向前平夾使兩拳擺至兩肩上，拳心朝下，同時兩拳弧形收抱腰間。

Requirements: Horizontally clamp up the elbows forward, making both fists placing on the shoulders, the center of fists are face down, and both fists are arched around the waist.

✿ 並步衝拳推掌
Folding stance punching fists pushing palm

✿ 身體直立不變，右拳向右側衝出；左拳變掌，向左側立掌推出；頭向右移，目視前方（圖 6）。

The body stands upright remains unchanged, the main right fist punch to the right; left fist changes to palm, erect the palm the push to the left; swing the head to the right, look forward (Fig. 6).

要求：兩肘向前平夾使兩拳擺至兩肩上，拳心朝下，同時兩拳弧形收抱腰間。

Requirements: Punch fist, push palm, and swing head at the same time.

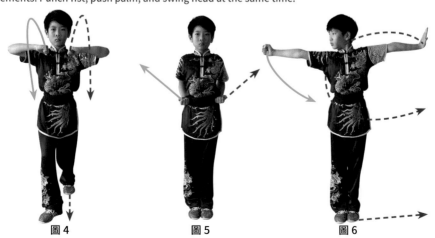

圖 4 圖 5 圖 6

半馬步按掌
Semi-horse stance pressing palm

左腳向左上步，兩腿屈膝，成半馬步，左掌劃弧向下，向前按，掌心朝下。右拳收抱右腰側，拳心朝上。目視左掌（圖 7）。

Left foot steps forward to the left, bend both knees and form a semi-horse stance, draw an arc downwards with left palm, press forward, the center of palm face down. Place right fist beside right waist, with the center of the fist facing upwards. Look at the left palm (Fig. 7).

要求：半馬步：兩腳分開，間距約三腳長，右腳尖正對前方，左腳尖外展，斜向前方，上體正直，收胯，提臀。

Requirements: Semi-horse stance: Separate both feet, spacing about three feet in width, right tiptoe face the front, left tiptoe outstretched, diagonally forward, the upper body is upright, draw in the hipbone, lift up the hip.

弓步衝拳发聲
Bow stance punching fist

右腿蹬直，左腿屈膝，成左弓步；右拳向前衝出，拳眼向上。左掌收於右臂內側，掌心朝右。目視右拳前方，發聲可發"嗨"（圖 8）

Push the right leg straight, bend the left knee, forming a bow stance; the main right fist punches forward, with the eye of the fist facing upward. Place the left palm close to the inside of the right arm, with the center of the palm facing right. Look at the right fist (Fig. 8).

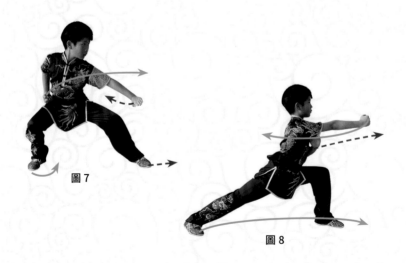

圖 7

圖 8

要求：弓步衝拳，要力達拳面，注意擰腰，蹬跟轉胯。弓步衝拳要發聲。

Requirements: Bow stance punching fist, pull back, and punch fist should be coherent and without stopping in the middle, bow stance, semi-horse stance, bow stance conversion should be flexible, pay attention to turning the waist, turning the heel, and turning the hipbone. Bow stance punch fist should make a sound.

✦ 騎龍步推爪
Dragon-riding stance pushing claw

✦ 右腳向前上步，腳外展。左腳跟上抬，兩腿屈膝，成騎龍步；右拳變爪，收至右肩前，爪心朝前。左手變爪，向前推出，爪心朝前，目視前方（圖9）。

Right foot step forward, with toes outstretched. Lift up the left heel, bend both knees, forming a dragon-riding stance; right fist changes to a claw, withdraw it to the front of the right shoulder, with the center of claw facing forward. Change the left hand to a claw, push it forward, with the center of claw facing forward, look forward (Fig. 9).

要求：推爪于收爪應同時進行，騎龍注意，兩腿屈膝，後腿膝關節接近地面，兩腳間相距兩腳長。

Requirements: Push the claw and draw back the claw at the same time. Pay attention when forming the dragon-riding stance, bend both knees, the knee joint of the hind leg should be close to the ground, both feet should be spacing about two feet in width.

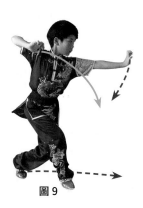

圖9

❂ 馬步雙切橋
Horse stance cutting bridge

❂ 左腳向前上步，身體稍右轉，兩腿屈膝，成馬步；兩臂內旋，向前下切，使兩爪變掌，掌心朝下，掌指相對，置胯前，目視兩掌（圖 10）。

圖 10

Left foot step forward, slightly turn right, bend both knees, forming a horse stance; rotate both arms inwards, cut forward and downward, changing both claws to palms, the center of palms face down, palms fingers facing each other, place both palms in front of the hipbones, look at both palms (Fig. 10).

要求：切橋力達兩掌外沿，騎龍步變馬步，注意左腳尖內扣，落地後再切橋。

Requirements: The force of cutting bridge reaches the outer edge of two palms, change the dragon-riding stance to horse stance, mind the inner buckle of the left tiptoe, cut the bridge after touching the ground.

❂ 馬步左右截橋
Horse stance left right fending with bridge

❂ 馬步不變，左前臂外旋向左格擋，手心朝內，掌指尖于眉相齊，右掌不變；目視前方（圖 11）。

Remain the horse step unchanged, left forearm rotate outwards，parry to the left, the center of palm face inside, the height of the palm fingertips are level with the eyebrows, left palm remains unchanged; look forward (Fig. 11).

❂ 左前臂內旋，經胸前劃弧收於左腰側，掌心朝下；同時右前臂外旋向右格檔，手心朝內。左掌不變；目視前方（圖 12）。

Rotate the left forearm inwards, draw an arc through the front of the chest and draw it back to the leftwaist, with the center of the palm facing down; at the same time, rotate the right forearm outwards and parry to the right, with the center of the palm facing inwards. The left palm remains unchanged; look forward (Fig. 12).

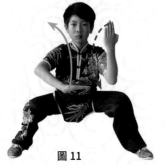

圖 11

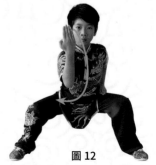

圖 12

✿ 右前臂內旋，經胸前劃弧收於右腰側，掌心朝下，目視前方（圖 13）。

Rotate the right forearm inwards, draw an arc through the front of the chest and draw it back to the right waist, with the center of the palm facing downwards, and look forward (Fig. 13).

要求：左右截橋力達前小臂外側。

Requirements: The force of left and right fending with bridge reaches the outside of the forearms.

✿ 馬步單指雙盤橋
Horse stance single finger circling bridge

✿ 右掌變單指向左向上，經臉前向右繞行，置體右前，掌心朝前，單指朝上，高于眼平，右臂略屈。目視右手。左掌變單指向右向上，經臉前向左繞行，置體左前，掌心朝前，單指朝上，左臂略屈。目視左手（圖 14）。

Right palm change to single finger, move to the left and upwards, bypass to the right in front of the face, place it in front of the right, the center of palm faces forward, single finger face up to eye level, slightly bend the right arm. Look at the right hand. Change the left palm to single finger, move to the right and upwards, bypass to the left in front of the face, place it in front of the left, the center of palm faces forward, single finger faces up, slightly bend the left arm. Look at the left hand. (Fig. 14).

要求：以肘為軸，繞環雙臂，右單指向上運行時，左單指隨之向右運行。單指：除食指伸直外，其餘四指變屈。

Requirements: Use the elbow as the axis, loop the arms, when the right single finger moves upward, the left single finger moves to the right along with it. Single finger: Other four fingers become flexed except for the index finger straightened.

圖 13　　　　　　　　　　　　圖 14

馬步雙沉橋推指

Horse stance sinking bridge pushing with finger

兩臂屈肘上抬至肩上，兩手指置頭側後，掌心朝上，掌指朝後。目視左手（圖15）。兩臂屈肘向前，向下，向後沉挫，使單指落於腰兩側，掌心朝下，指尖朝前。目視右手（圖16）。

Bend the elbows and lift them up to the shoulders, place the two fingers behind the head, with the center of palms facing up, and the fingers of palms facing back. Look at left hand (Fig. 15). Bend the elbows forward, then downwards, sinking the bottom backward, making the single finger falls on both sides of the waist, the center of palm facing down, and fingertips facing forward. Look at the right hand (Fig. 16).

兩單指向下，向上，向前推出，掌心朝前，掌指朝上，目視前方（圖17）

Two single fingers face down, then upwards, and push forward, the center of palms face forward, palm fingers face up, look forward (Fig. 17).

要求：臂的沉挫，單指向前推，都需要使臂部肌肉保持適度的緊張性，以獲得緩緩用勁的效果。
沉橋：屈臂，使前臂由上向下挫沉，力達前小臂。

Requirements: Both the sinking of the arm and the forward pushing of the single finger need to maintain the arm muscles moderately tense in order to obtain the effect of slow exertion. Sinking bridge: Bend the arm to make the forearm sink from top to bottom, the force reaches the forearm.

馬步雙標挑掌

Horse stance thrusting snap palm

兩臂屈肘上抬至肩上，兩手單指置頭側後，掌心朝上，掌指朝後，目視右手（圖18）。兩臂屈肘向前，向下，向後沉挫，使單指於腰兩側，掌心朝裡，指尖朝前，目視右手（圖19）。兩手單指變掌，上抬至胸前，再向前標出，兩掌心相對，掌指朝前，高於肩平（圖20）。兩手腕部朝虎口側屈，使指上挑，掌心分別朝左前，右前。指尖朝上，高于口平。（圖21）。

Bend the elbows and lift them up to the shoulders, place two hands with single finger behind the head, the center of palms face up, palm fingers face backward, look at right hand (Fig. 18). Bend the elbows forwards, then downwards, and sink backward, so that the single fingers fall beside the waist, the center of palms face inside, fingertips face forward, look at right hand (Fig. 19). Change both single fingers to palm, lift it up to the chest, and thrust them forward, the center of palms face each other, palm fingers facing forward and place them higher than shoulders (Fig. 20). Bend both wrists to the side of the purlicues, lift your fingers up, the center of palms face toward the front left and front right respectively. Fingertips face up, with the same height as the mouth. (Fig. 21).

要求：標掌：馬步要挺胸、立腰，臂短促有力前伸。力達掌指尖。標掌要快速有力。力達掌指尖瞬時屈腕上挑掌。挑掌：直臂或屈臂，屈腕，掌由下向上挑，力達四指。

Requirements: Thrusting palm: Straighten the waist and in line with the arm. Push the arms forward with force reaches fingertips. The thrusting palm should be fast and powerful. Bend the wrists and snap palm instantly when the force reaches fingertips. Snap palm: Straighten or bend the arms, bend the wrists, lift the palm from the bottom to the top, with force reaches four fingers.

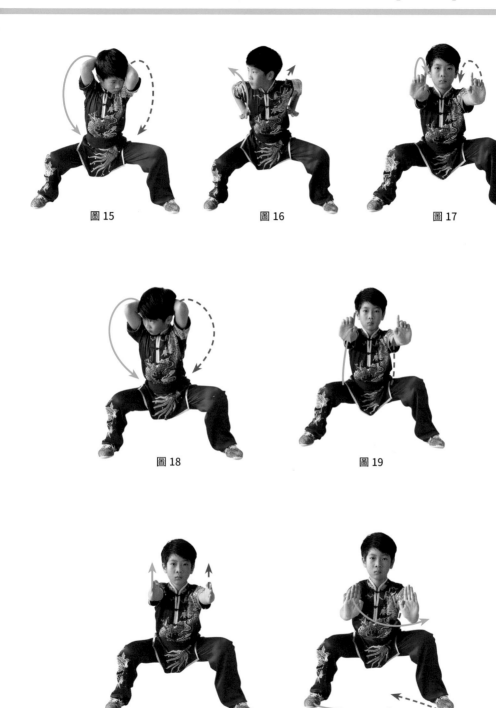

圖 15　　　　　　圖 16　　　　　　圖 17

圖 18　　　　　　圖 19

圖 20　　　　　　圖 21

弓步雙架橋
Bow stance blocking bridge

兩腳蹬離地面，身體騰空左移，兩腳落地成馬步；兩掌交叉向下，向兩側分開至胯側，變拳收抱腹前，兩拳心向裡，拳眼朝上，目視前方（圖22）。身體右移，右腿屈膝，左腿蹬直，成右弓步；同時兩拳內旋架於頭頂上方；目視兩拳（圖23）。

Push the feet off the ground, leap up and move the body left, land the feet to a horse stance; cross the palms down, separate them to the sides of the hipbone, change the palms to fists and withdraw them to the front of the belly, the centers of fists face inside, the eyes of fists face up, look forward (Fig. 22). Move the body to the right, bend the right knee, push the left leg straight, form a right bow stance; at the same time, rotate two fists internally and parry them above the head; look at two fists (Fig. 23).

要求：兩腳蹬離地面，騰空不宜太高，隨轉身兩腳同時落地；架橋時借助轉腰之力，兩臂有外撐之意，力達兩前臂外側。

Requirements: Push the feet off the ground, do not leap up too high, land with both feet at the same time as turning around; use the force of turning the waist when blocking bridge, both arms prop up, with the force reaching the outer edge of the forearms.

單蝶步右砍掌
Single fold step right chopping palm

左腳向左前上步，屈膝。右腳略向前移步，小腿于腿內側著地，成單蝶步；左拳收抱于腰左側，右拳變掌向下，向上平砍，掌心朝上，力達小拇指側外沿，目視前方（圖24）。

Left foot steps forward and bend the knee. Slightly move right foot forward, touch the ground with the shank and the inner side of the leg to form a single fold step; withdraw the left fist to the left side of the waist, change the right fist into a palm and move downwards, level cut upwards, the center of palm faces up, with the force reaches the outer edge of the thumb. Look forward (Fig. 24).

要求：砍掌用右臂的外旋向前力，使力達右掌小指側掌根部。蝶步：一腿屈蹲，另一腿腳內側于小腿內側著地。

Requirements: Cut the palm with the force of the right arm rotating outwards and forward, so that the force reaches the outer edge of the right hand little finger and the base of the right palm. Fold step: squat with one leg, and touch the ground with the shank and the inner side of the other leg.

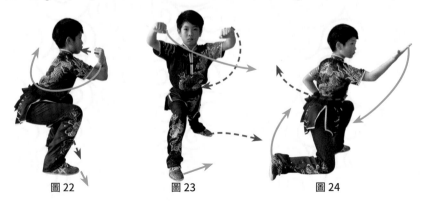

圖 22　　　　圖 23　　　　圖 24

✿ 右弓步衝左拳
Right bow stance punching left fist

✿ 身體稍立起，左腳內扣，膝略屈：身體右轉，右腳向右後方上步，屈膝半蹲，左腿挺膝伸直，成右弓步；右掌變拳收抱於右腰側，拳心朝上；左拳隨轉身，向左前方立拳衝出。目視左前方（圖 25）

Slightly straighten the body, buckle the left foot inwards, slightly bend the knee: turn right, step the right foot to the rear right, bend the knee and semi-squat, stretch the left leg and straighten the knee to form a right bow stance; change the right palm to a fist and withdraw it to the right waist, the center of fist faces up; erect and punch the left fist to the front left as turning the body. Look forward (Fig. 25).

要求：身體右轉于左腳扣和右腳上步，協調一致。

Requirements: Turn right, coordinate with the left foot buckle, and the right foot step forward.

✿ 左弓步衝右拳
Left bow stance punch right fist

✿ 身體左轉，左腿屈膝半蹲，右腿挺膝伸直，成左弓步；左拳收抱于左腰側，拳心朝上；右拳隨轉身向右立拳衝出，拳于肩高。目視右前方（圖 26）

Turn left, bend the left knee and semi-squat, stretch the right leg and straighten the knee to form a left bow stance; with draw left fist to the left waist, the center of fist faces up; erect and punch the right fist to the right as turning the body, with the same height as the shoulders. Look forward (Fig. 26).

要求：同前動作

Requirements: Same as the previous form

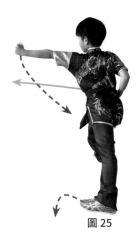

圖 25

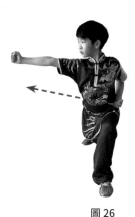

圖 26

少兒小南拳

✿ 並步抱拳
Folding stance holding fists

✿ 身體稍右轉，兩腿微屈：右拳變平拳，左拳向前平拳衝出。目視前方（圖 27）。身體立起，兩腳同時並步；兩臂屈肘，內旋向下，向後，再外旋，向上，向前繞環，使兩拳收抱腰側，拳心朝上，目視前方（圖 28）。

Slightly turn right, slightly bend both legs: the right fist becomes a level fist, level punches the left fist forward. Look forward (Fig. 27). Body upright and form a folding stance at the same time; bend both elbows, internally rotate them downwards, backward, then rotate externally, upwards, and loop forward, so that the fists are withdrew to the sides of the waist, the centers of fists face up. (Fig. 28).

要求：兩腳蹬離地面不可過高；兩臂環繞不要太大；並步抱拳需挺胸，立腰。

Requirements: Both feet should not be too high off the ground; do not loop the arms too large; erect the chest in holding stance, erect the waist as well.

✿ 蓋步左蹬腿
Forward crossover step left kicking leg

✿ 右腳向前蓋步，腳尖外展，兩腿屈膝。目視前方（圖 29）。
左腳屈膝上抬勾腳尖，向前蹬出，目視前方（圖 30）。

Right foot step forward crossover, outstretch the tiptoe, bend both knees. Look forward (Fig. 29). Bend the left knee, lift up the tiptoe, kick forward, look forward (Fig. 30).

要求：蹬腿時膝伸直，腳尖勾起，力達腳跟。

Requirements: Straighten the knees when kicking, lift up the tiptoes, the force reaches the heel.

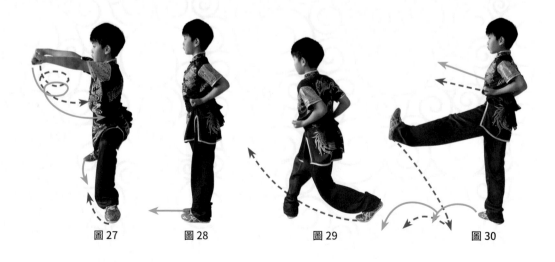

圖 27　　　圖 28　　　圖 29　　　圖 30

✤ 躍步跪步雙推爪（發聲）
Leaping step squatting stance pushing claw

✤ 左腳向前落步，兩膝稍屈。右腿屈膝上抬，左腳蹬離地面，人體騰空。右腳向前下落，前腳掌著地。左腿屈膝上抬，腳底朝後，腳尖朝下，靠於右膝側。右腳後跟著地，左腳向前落地，兩腿膝略屈。左腿屈膝下蹲，右腿膝略前移，屈膝，腳跟離地臀坐於右小腿上，成跪步；兩拳變爪，向前推出，爪心朝前。（圖31）。

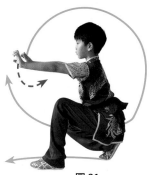

圖 31

Left foot steps forward, slightly bend the knee. Bend the right knee and lift it up, leap up and kick the left foot, the body be high up in the air. Drop the right foot forward, with the forefoot landing on the ground. Bend the left knee and lift it up, with the sole of the foot facing back and tiptoe facing down, leaning against the side of the right knee. Touch the ground with right foot heel, left foot land forward on the ground, with both knees slightly bent. Bend the left knee and squat, slightly move the right leg forward, bend the knee, sit on the right shank with the heel off the ground, form a squatting stance; change both fists to claws, push forward, the center of claws face forward. (Fig. 31).

要求：先前躍步騰空不過高，上體要平穩，不可前傾；屈蹲成跪步。跪步：一腿屈膝全蹲。另一腿屈膝，使膝部接近地面，腳跟離地，臀部坐於小腿上面。爪：五指用力張開，第二，三指骨盡量向手背一面伸張，使掌心凸出。

Requirements: the previous leaping step should be not too high, keep the balance of the upper body, do not lean forward; squat to form a squatting stance. Squatting stance: Bend one knee and squat fully. Bend the other leg, so that the knee is close to the ground, lift the heel off the ground, the hip sits on the shank. Claw: stretch five fingers open with force, and stretch the second and the third finger bone as close as possible to the back of the hand, so that the palm protrudes.

✤ 騎龍步撩拳
Dragon-riding stance upper-cutting fist

✤ 右腳向前上一步，屈膝。左腳跟半步，腳跟抬起，成騎龍步；右手變拳，向上，向後，向前繞一立圓撩拳，拳心于嘴同高；左手變掌附於右小臂上，掌心朝下。目視前方（圖32）。

Right foot steps forward, bend the knee. Take a half step back with the left heel, lift the left heel, form a dragon-riding step; change the right hand to a fist, faces up, backward, and forward to erect a circle with upper-cutting fist, the center of the fist with the same height as the mouth; change the left hand to a palm and attach it to the right arm, the center of palm face down. Look forward (Fig. 32).

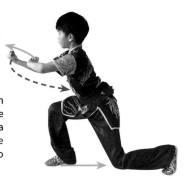

圖 32

要求：右拳繞環，眼隨拳轉；左掌附在右前臂時可做响

Requirements: The eyes follow the right palm movement; left palm attached to the right forearm can be done

虛步切橋
Empty step cutting bridge

右腳向後稍移，前腳掌著地。兩腿稍屈，成高虛步；右拳收抱右腰側。左
掌順著右前臂向前橫切，掌心朝下，臂稍屈。目視前方（圖33）。

Slightly move the right foot back, with the forefoot touching the ground. Bend both
knees to form an empty step; withdraw the right fist to the side of the right waist.
The left palm is cut horizontally forward along the right forearm, the center of the
palm is face down, slightly bend the arm. Look forward (Fig. 33).

要求：切橋力達小拇指側。

Requirements: The force of cutting bridge reaches the side of the thumb.

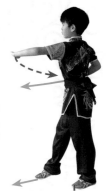

圖 33

馬步按掌
Horse stance pressing palm

身體左轉，右腳內扣，兩腿屈膝半蹲，成馬步，右手變掌隨轉身
向右下方按出，掌心朝下，指尖朝前。左掌屈肘收於右胸前成立
掌，目視右按掌（圖34）

Turn left, buckle the right foot, bend both knees with half squat, form
a horse stance, change to right hand to a palm as turning around and
pressing it out to the right bottom, the center of palm faces down,
fingertips face forward. Bend the left palm and withdraw it in front of the
right chest to erect the palm, look at the right pressing palm (Fig. 34).

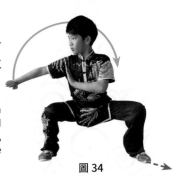

圖 34

要求：右腳內扣轉身成馬步；按掌力達掌根。

Requirements: The inner buckle of the right foot change to a horse stance while turning the body; the force
of pressing palm reaches the base of the palm.

騎龍步壓肘
Dragon-riding stance pressing elbow

身體微左轉，兩腿屈膝，右腳跟抬起，成騎龍步；左掌向上，向前，
向下附於右前臂上。右掌變拳，向上，向前滾肘下壓，拳心向上，
拳於肩高。目視右拳（圖35）。

Slightly turn left, bend both knees, lift the right heel, form a dragon-riding
stance; move the left palm upward, forward, and downward, and attach it
to the right forearm. Change the right palm to a fist, move it upward and
forward to rotate, and press the elbow downward, the center of fist faces up,
with the same height as the shoulder. Look at the right fist (Fig. 35).

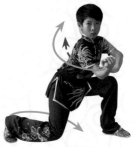

圖 35

要求：滾肘下壓，力達右前臂。左掌附於右前臂內側，整個動作要連貫。

Requirements: The force reaches the front right when rotating and pressing the elbow. The left palm is
attached to the inner edge of the right forearm, the whole movement should be coherent.

✿ 收勢
Closing form

✿ 身體稍右轉，兩腿屈膝；右拳內旋收至右肩前，拳心朝下。左掌向右放至右拳前，掌指朝上。目視兩手（圖 36）。

Slightly turn right, bend both knees; rotate the right fist inwards and withdraw it to the front of the right shoulder, the center of fist faces down. Move the left palm to the right and place it in front of the right fist, palm fingers face up. Look at both hands (Fig. 36.).

✿ 右腿屈膝，左腳向前移步，前腳掌著地，左腿略屈，成左虛步；左掌向前平推，掌心朝前。同時，右拳向前平衝，力達拳面，兩手高於肩平（圖 37）。左腿退一步，右腳退半步，于左腳併攏，兩腿伸直；兩臂向下，向外旋，再向後下落，左掌變拳，兩拳收抱於腰兩側。目視左前方（圖 38）。兩拳變掌落於體兩側。目視前方（圖 39）。

Bend the right knee, left foot steps forward, with the forefoot touching the ground, slightly bend the left leg to form an empty step; horizontally push the left palm forward, the center of the palm face forward. At the same time, the right fist balance forward, the force reaches the face of the fist, with both hands above the shoulder level (Fig. 37). Left foot step backward, right leg takes a half step back, standing side by side with the left leg, straighten both legs; both arms move downwards, rotate outwards, then drop on the bottom back, change the left palm to fist, withdraw both fists to the sides of the waist. Look at the front left (Fig. 38). Change both fists to palms and place them to the sides of the body. Look forward (Fig. 39).

要求: 兩臂擺至肩前時，應迅速地屈肘；兩臂外旋後，收抱於腰兩側動作應于兩腳並步同時完成。

Requirements: Bend your elbow quickly when swinging both arms to; after rotating both arms outwards, withdrawing them to the sides of the waist should be completed at the same time as standing both feet side by side.

圖 36

圖 37

圖 38

圖 39

三字經武術

🔹 抱拳禮
Salute with fist

🔹 兩臂屈肘上抬，左手拇指屈攏，其餘四指併攏伸直；右手握拳，左掌心緊貼右拳面于胸前 20-30 釐米處；目視前方（圖 1）

Bend and lift the elbows, flex the left thumb inwards, straighten and place the other four fingers close together; right hand holds a fist, attach the center of left palm closely to the face of the right fist and place them 20-30 cm in front of the chest; look forward (Fig. 1).

要求：兩手臂環抱于胸前，右拳面貼在左掌心指節下方，左掌指尖於嘴同高。

Requirements: Encircle the arms in front of the chest, attach the face of right fist under the knuckles of the left palm, the fingertips of the left palm are at the same height as the mouth.

🔹 人之初 ，開立步雙衝拳
At the beginning of life, spread feet stance punching fists

🔹 左腳向左橫跨一步成開立步；左手變拳，兩手收抱于腰間，拳心向上，兩拳由腰間旋臂向前衝出，力達拳面；目視前方（圖 2）

Horizontally step the left foot to the left to form a spread feet stance; change the left hand into a fist, withdraw both hands to the sides of the waist, the center of fists face up, rotate both arms and punch both fists to the front from the sides of the waist, the force reaches the face of the fists; look forward (Fig. 2).

要求：開立步要抬頭，挺胸，收復，立腰；雙衝拳與肩同高。

Requirements: Head up in spread feet stance, chest out, constrict belly, erect waist; punch fists with the same height as the shoulders.

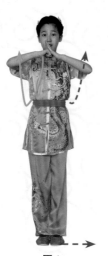
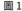
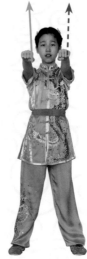

圖 1　　　　圖 2

✿ **性本善， 開立步向上推掌**

 Man is good in nature, spread feet stance pushing palms upward

✿開立步不變，兩手屈回拉至胸前，變掌直臂向上推出，兩掌心斜向上方，目視前上方（圖 3）

Remain the spread feet stance unchanged, bend both hands back and pull them in front of the chest, change both hands into palms and push them straight up, the center of both palms face up diagonally, look at upper front (Fig. 3).

要求：向上推掌，兩臂要直，目視兩手間。

Requirements: push the palms upwards, with the arms straightened, look at the middle of both hands.

✿ **性相近，開立步勾手**

 Human nature is alike, spread feet stance hook hands

✿開立步不變，兩手向兩側直臂下落，變勾手平舉；甩頭向右，目視前方（圖 4）

Remain the spread feet stance unchanged, drop both hands to the sides with the arms straightened, change both hands into hooks and raise them horizontally; swing the head to the right, look forward (Fig. 4)

要求：勾手兩臂要平穩。

Requirements: The arms should be horizontally steady with hook hands.

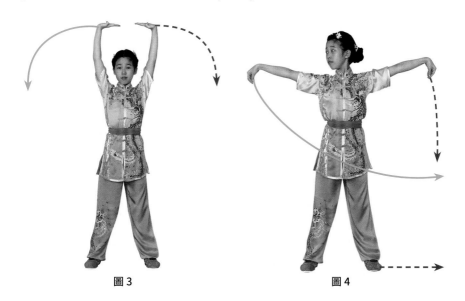

圖 3 圖 4

✿ 習相遠。左弓步右撩掌
Habits make them different, left bow stance right arc palm

✿ 身體左轉，左腿向左側進半步，屈膝半蹲，右腿挺腰伸直
成左弓步；右手變掌隨轉身向下，向前撩出，掌心向上；
撩至膝關節前方；同時左手變掌屈肘附於右小臂上；目視
前方（圖 5）

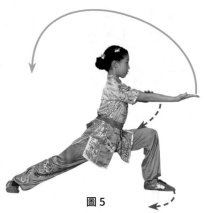

Turn left, bend the left leg and semi-squat, straighten the right leg and erect the waist, form a left bow stance; change the right hand into a palm and arc the palm downward, then forward when turning the body, center of palm faces up; arc it till the front of the knee joint; at the same time change the left palm into a palm and bend it, attach it to the right arm; look forward (Fig. 5).

圖 5

要求：弓步，前腳稍內扣，屈膝半蹲，大腿接近水平，膝蓋約垂直于腳尖或腳背；後腿挺
膝伸直，腳尖內扣，兩腳全腳著地。

Requirements: bow stance, slightly buckle the forefoot inwards, bend the knee and semi-squat, the thigh should be close to level, the knee should be approximately perpendicular to the toes or the back of the foot; straighten the rear leg and the knee, buckle the tiptoe inwards, booth feet landing on the ground.

✿ 苟不教，馬步右砍掌
For lack of education, horse stance right chopping palm

✿ 身體右轉，兩腿屈膝半蹲成馬步；右手隨轉身向右側砍掌，
手與肩同高，左手變拳屈肘收回左腰間，拳心向上；頭向
右甩，目視前方（圖 6）

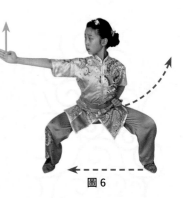

Turn right, bend both knees and semi-squat to form a horse stance; chop the right palm to the right when turning the body, the hand should be at the same height as the shoulder, change the left hand to a fist and bend it, withdraw it to the side of the left waist, center of fist faces up; swing the head to the right, look forward (Fig. 6).

圖 6

要求：馬步兩腳相距，約本人三腳，兩腿屈膝半蹲，大腿接近水平，膝關節約垂直于腳尖，
兩腳正直前方；砍掌力達掌外沿；要挺胸，塌腰。

Requirements: In horse stance, two feet should be in distance of three feet, bend both knees and semi-squat, the thigh should be close to level, the knee joint should be approximately perpendicular to the tiptoes, both feet point forward; the chopping force reaches the external edge of the palm; chest out, sink waist.

✿ 性乃迁，丁字步勾手推掌
The nature is in alteration, T-shaped stance hook hand pushing palm

✿ 身體立起，兩腿併攏，左腳跟收於右腳內側成丁字步；同時右掌變勾手，左掌向左側方推出；頭轉向左側方，目視前方（圖 7）

Erect the body, both feet stand closely together, withdraw the left heel to the inner edge of the right foot to form a T-shaped stance; at the same time change the right palm into a hook hand, push the left palm to the left; turn the head to the left, look forward (Fig. 7).

要求：身體直立變勾手稍頓，甩頭推掌同時進行。注意節奏。

Requirements: Body upright and change into a hook hand for a while, swing the head and push the palm at the same time. Pay attention to the rhythm.

✿ 教之道，半馬步左格拳
The nature of the young, semi-horse stance left blocking with fist

✿ 左腳向左前方邁一步，腳尖斜向前，兩腿屈膝半蹲成半馬步；左掌向下外旋向上劃弧成格掌，掌心向內；右手變拳屈肘收抱右腰間，拳心向上；目視前方（圖 8）

Left foot step on to the front left, with the tiptoes diagonally forward, bend both knee and semi-squat to form a semi-horse stance; internally rotate the left palm downward and circle an arc upward to form a blocking palm, the center of palm faces inside; change the right hand into a fist and bend it, withdraw it to the side of the right waist, center of fist faced up; look forward (Fig. 8).

要求：半馬步時身體面向 45 度角，左腿膝關節正對左前方；左格掌，力達姆指側。

Requirements: Face the body at a 45-degree angle in semi-horse stance, with the knee joint of the left leg facing the front left; left blocking with palm, the force reaches the side of the thumb.

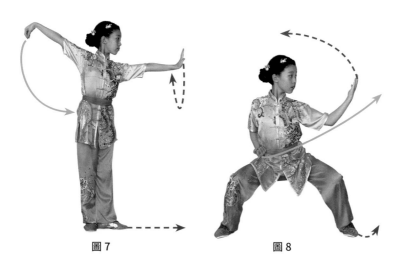

圖 7　　　　　　　　圖 8

貴以專，弓步架衝拳

Better be maintained for long, bow stance blocking punch fist

身體微左轉，左腿屈膝半蹲，右腿挺膝伸直成左弓步，左掌屈肘上架，右拳向前平拳衝出；目視前方（圖 9）

Slightly turn left, bend the left knee and semi-squat, straighten the right leg and knee to form a left bow stance, bend the left palm and upward blocking, erect and punch the right fist to the front; look forward (Fig. 9).

要求：左掌上架與右手衝拳同時進行。

Requirements: Upward blocking with the left palm and punching fist with the right hand at the same time.

昔孟母，分手彈踢

Once Mencius's mother, parting hands flip kicking

左手向下落搭在右手腕上，兩手同時向下分手向後變勾手；同時左腿稍屈站起，支撐身體重心，右腿隨即由屈到伸，繃腳面向前彈出；目視前方（圖 10）

Drop the left hand down on the right wrist, part both hands downward and backward at the same time and change them to hook hands; at the same time straighten the left leg to support the center of gravity, right leg then straightened from bent, stretch the instep tightly and flip the leg to the front, look forward (Fig. 10).

要求：整個動作要連貫，一氣呵成；彈腿的支撐腿伸直或稍屈，彈出的腿力達腳尖。

Requirements: The whole movement should be coherent and completed in one go; the supporting leg of the flipping leg should be straightened or slightly bent, the force of the flipping leg reaches the tiptoes.

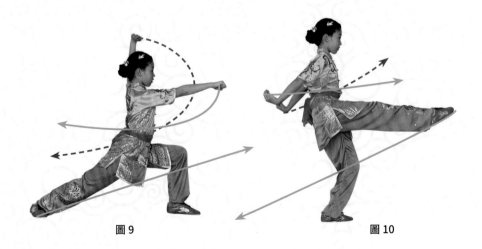

圖 9　　　　　　　　　　圖 10

擇鄰處，左弓步雙推掌

Chose the best neighbourhood for her son, left bow stance pushing palms

左腿屈膝下蹲，右腿後撤還原成左弓步；兩手變掌，經兩腰側向前立掌推出；目視前方（圖 11）

Bend the left knee and squat, withdraw the right leg to form a left bow stance; change both hands into palms, erect and push the palms forward through the sides of the waist; look forward (Fig. 11).

要求：雙推掌兩臂要伸直，掌指尖與眉同高。

Requirements: straighten both arms when pushing the palms, the fingertips of the palms should be at the same height as the eyebrows.

子不學，轉身右弓步右劈拳

When her son played truant, turn the body right bow stance right chopping fist

身體右轉，右腿屈膝半蹲，左腿隨轉身挺膝伸直成右弓步；兩掌變拳，右手向上向右前劈拳，拳眼向上；左手變拳屈肘收於腰間，頭轉向右側，目視前方（圖 12）

Turn right, bend the right knee and semi-squat, straighten left leg and knee when turning the body to form a right bow stance; change both palms into fists, chop the right fist upward and to the front right, with the eye of the fist facing upward; bend the left elbow and withdraw the fist to the side of the waist, turn the head to the right, look forward (Fig. 12).

要求：轉身弓步與劈拳同時進行；劈拳力達拳輪。

Requirements: Turn the body to form a bow stance and chop the fist at the same time; the force of chopping fist reaches the curve of the fist.

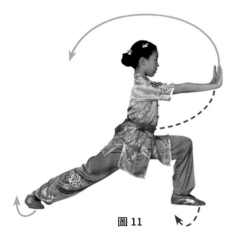

圖 11

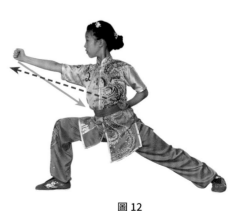

圖 12

✿ 斷機杼，右弓步左推掌

She cut the threads on the loom, right bow stance left pushing palm

✿ 右弓步不變，左手變掌向前立掌推出；右拳收抱于腰間；目視前方（圖 13）

Remain the right bow stance unchanged, change the left hand into a palm, erect and push it to the front; withdraw the right fist to the side of the waist; look forward (Fig, 13).

要求：弓步上身不可前俯後仰，左右歪斜。

Requirements: Do not lean the upper body forward or backward on bow stance, or slant from side to side.

✿ 竇燕山，提膝上衝拳接并步砸拳

Another case is DouYan mountain, raising knee upward-punching fist then folding stance hammer strike

✿ 身體左轉直立，右腿屈膝提起，右腳扣于左腿成提膝；左手隨轉屈肘經胸前向左側平推成立掌；右拳向上衝出；目視正前方（圖 14）隨即右腳下落震腳，兩腿屈膝半蹲左手屈肘收於腹前，掌心向上；右拳隨屈蹲下落，拳背砸于左手心作響；目視前方（圖 15）

Turn left and stand upright, bend and raise the right leg, buckle the right leg to the left leg to form a raising knee; bend the left elbow when turning the body, horizontally push the left hand to the left to form an erecting palm through the chest; punch the right fist upward; look forward (Fig. 14). Then, drop and stamp the right foot, bend both knee and semi-squat, bend the left elbow and withdraw it in front of the belly, the center of palm faces up; drop the right fist when squatting, strike the back of the fist to the center of the left hand to make a sound; look forward (Fig. 15).

要求：提膝身體要立直，支撐腿不可彎屈；半蹲與砸拳同時進行，上體不可前傾；整個動作要連貫園活。口令運用時：竇—提膝上衝拳—空 1 拍（燕）-- 并步半蹲砸拳（山）。

Requirements: The body should stand upright when raising the knee, do not bend the supporting leg; semi-squat and hammer strike at the same time, do not lean the body forward; the whole movement should be coherent. The use of command: 'Dou'—raise the knee and punch the fist upward, rest for a beat, 'Yan'—folding stance semi-squat hammer strike, 'Shan'.

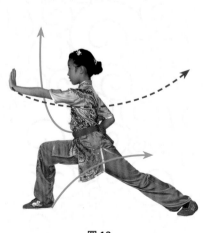
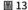
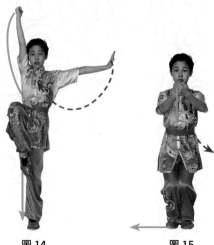

圖 13　　　　　　　　　圖 14　　　　　　　　　圖 15

🌀 有義方，開立步左右衝拳接騎龍步右衝拳

Who was wise in family education, spread feet stance left right punching fists, then dragon-riding stance left punching fist

🌀 身體立起，右腳向右橫跨一步成右開立步；右手變拳向前平拳衝出；左手收抱于左腰間，拳心向上；目視前方（圖16）；開立步不變，左手向前平拳衝出，右拳收於腰間；目視前方（圖17）；身體微右轉，左腳稍外展，左腿屈膝半蹲，右腿屈膝，腳跟上抬，成騎龍步；右拳平拳向前衝出，左拳收抱腰間，拳心向上；目視前方（圖18）

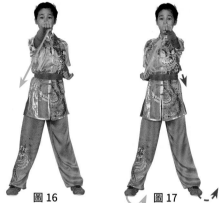

圖 16　　圖 17

Body upright, right foot horizontally step to the right to form a spread feet stance; change the left hand into a fist, erect and punch it forward; withdraw the right hand to the side of the right waist, the center of fist faces up; look forward (Fig. 16); remain the spread feet stance unchanged, erect and punch the right fist forward, withdraw the left fist to the side of the waist; look forward (Fig. 17); slightly turn right, slightly outstretch the right foot, bend the right knee and semi-squat, lift the heel, form a dragon-riding stance; erect the left fist and punch it forward, withdraw the right fist to the side of the waist, the center of fist faces up; look forward (Fig. 18).

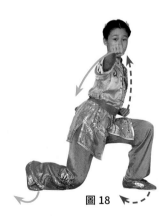

圖 18

要求：口令：每拍一字，有—開立步右衝拳，義—開立步左衝拳，方—騎龍步右衝拳。

Requirements: command: one word in each beat, 'You' —spread feet stance right punching fist, 'Yi' — spread feet stance left punching fist, 'Fang' —dragon-riding stance right punching fist.

🌀 教五子，開立步左右衝拳接騎龍步右衝拳

He raised his five sons, spread feet stance left right punching fists , then dragon-riding stance right punching fist

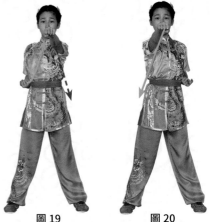

圖 19 圖 20

🌀 身體立起成開立步，左手平拳向前衝出；右拳收於腰間，拳心向上；目視前方（圖19）；隨即右拳平拳向前衝出，左拳收抱于腰間，拳心向上，目視前方（圖20），身體微右轉，右腳稍外展，右腿屈膝半蹲，左腿屈膝，腳跟上抬，成騎龍步；左拳平拳向前衝出，右拳收抱腰間，拳心向上，目視前方（圖21）

Body upright to form a spread feet stance, erect and punch the right fist forward; withdraw the left hand to the side of the waist, the center of fist faces up; look forward (Fig. 19); Then, erect and punch the left fist forward, withdraw the right fist to the side of the waist; the center of fist faces up, look forward (Fig. 20); slightly turn left, slightly outstretch the left foot, bend the left knee and semi-squat, bend the right knee, lift the heel, form a dragon-riding stance; erect the right fist and punch it forward, withdraw the left fist to the side of the waist, the center of fist faces up; look forward (Fig. 21).

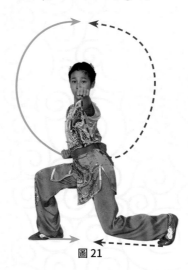

圖 21

要求：口令：每拍一字。教—開立步左衝拳，五—開立步右衝拳，子—騎龍步左衝拳。

Requirements: command: one word in each beat, 'Jiao' —spread feet stance right punching fist, 'Wu' —spread feet stance left punching fist, 'Zi' —dragon-riding stance right punching fist.

名俱揚。並步上擊掌接分手亮掌

And all of them were blessed with fame, folding stance upward-clapping palms, then parting hands flashing palm

身體立起，兩腿併攏直立；兩手向上，在頭頂上方擊掌；目視前上方（圖22）；右腳向右斜後方撤步，屈膝，左腿屈膝成半馬步；左手向下，右手向上分開成雙分掌；甩頭，目視斜前方（圖23）

Body upright, straighten both feet and stand closely together, hands up, clap the palms above the head; look at upper front (Fig. 22); withdraw the right foot diagonally to the right rear, bend the knee, bend the left knee to form a semi-horse stance; left hand moves downward, right hand moves upward, separate both hands to form a parting palm; swing the head, look diagonally forward (Fig. 23).

要求：並步上擊掌，右手背擊拍左手心作响；半馬步；兩腳相距本人三腳長，右腿屈膝半蹲成馬步，左腿稍屈，腳尖微內扣；分手亮掌，掌心向前。口令：名俱—並步上擊掌，揚—分手分掌。

Requirements: folding stance upward-clapping palms, the back of the right hand clap with the center of the left hand to make a sound; two feet should be in distance of three feet, bend the right knee and semi-squat to form a horse stance, slightly bend the left leg, slightly buckle the tiptoes inward; parting hands flashing palm, the center of palm face to the front. Command: 'MingJu' —folding stance upward-clapping palms, 'Yang' —Parting hands parting palms

抱拳禮

Salute with fist

身體立起右腳收於左腳內側，兩腿併攏直立；同時兩手環抱于胸前成抱拳禮。目視前方（圖24）

Body upright, withdraw the right foot to the inner edge of the left foot, straighten both feet and stand closely together; at the same time encircle both hands in front of the chest to form a salute with fist. Look forward (Fig. 24)

要求：同前抱拳禮

Requirements: Same as the salute with fist before

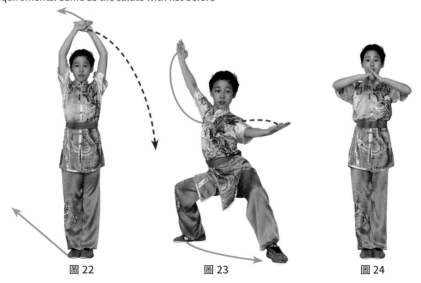

圖22　　　　圖23　　　　圖24

音樂功夫筆

❀ 筆，俗稱"判官筆"，是武術器械中短兵器的一種。由於器械短小，便於攜帶，所以也有人稱為暗器。攻防多能，演練起來即靈活又輕便，是民間護身防暴，受喜愛的一種兵器。它的運動技法，主要有刺，挑，抹，劈，絜，擺，帶，撩，掃，絞，圈等方法，配合上各種步型構成的套路，可單，雙，集體演練。這裏介紹的是配合音樂編製成的"功夫筆"。

Pen, commonly known as the " Negotiate Pen ", is one of the short weapons among the martial arts weapons. Since the weapon is short and is easy to carry, it is also called a hidden weapon. It has versatile offensive and defensive capabilities, and is flexible and light in drills. It is a popular weapon for civilian protection against riots. Its athletic techniques, mainly includes sharpening, snapping, wiping, chopping, thrusting, shoveling, withdrawing, wielding, sweeping, adjusting, circling, etc., cooperate with routines formed by various stances, may perform single, duo, or collective performance. The one introduced now is "Kung Fu Pen" complied with music.

筆尖　　　　筆桿　　筆把　筆首

❀ 筆是用金屬製成的，筆尖很犀利，攜帶演練要注意安全。

Pen is made of metal, the tip of the pen is very sharp, pay attention to safety when performing with it.

❀ 少年兒童可以換成長毛毛筆安全演練。

Teenage and children can change to a pen with long brush for safety.

❀ 預備式：兩腿併攏，身體直立，右手持筆屈肘上抬至胸前，握筆手心向內，筆尖向上，同時左臂屈肘上抬，左掌附在右持筆手指骨上，目視前方（圖 0-1）

Ready posture: Both feet standing side by side, body upright, right hand holds the pen, bend the elbow and lift it to the chest, the center of the hand holding the pen faces inward, the tip of the pen points upward, at the same time bend the left elbow and lift it up, attached the left palm to the right hand finger bone, look forward (Fig. 0-1).

要求：抬頭，挺胸，收腹，立腰；兩手環抱胸前 20—30 釐米處（音樂前奏曲）。

Requirements: head up, chest out, constrict the belly, erect the waist; encircle both hands in front of the chest in distance of 20-30 cm (music prelude), hold the pen in front of the chest and bow.

圖 0-1

雙手胸前托毛鞠躬

身體直立不變，左掌外旋向前伸，掌心向上，同時右持毛手內旋使毛橫在左掌上，兩臂伸直，目視前方（圖 0-2）．隨即上體前屈，兩臂下落，垂於體前成鞠躬。目視下方（圖 0-3）。身体直立，兩臂上抬，與肩同高，目視前方（圖 0-4）

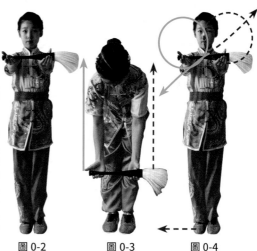

Maintain the body upright, externally rotate the left hand forward, the center of palm faces up, at the same time hold the pen with the right hand and internally rotate the hand so that the pen is horizontally attached to the left palm, straighten both arms, look forward (Fig. 0-2). Then immediately bend the upper body forward, lower both arms, and sagged in front of the body to bow down. Look downward (Fig. 0-3).

圖 0-2 圖 0-3 圖 0-4

要求：上體向前鞠躬近 90 度。

Requirements: The upper body bows forward nearly 90 degrees.

（臥似一張弓）右弓步拉弓勢

(Lying like a bow) Right bow stance drawing bow step

身體立起，兩臂交叉，右手在外，左掌在內，目視前方，兩臂上舉，兩手向兩側劃一圈，再收抱於胸前成交叉，目視前方。隨之右腳向右橫跨一步，屈膝半蹲，左腿挺膝繃直成右弓步；右手持毛屈肘向右拉至右肩前，手心向內，毛尖斜向前上。同時，左掌向左前上，立掌推出。目視左上方（圖 1）

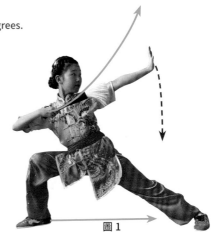

圖 1

Body upright, arms crossed, with right hand outside and left palm inside, look forward, raise both arms, draw a circle for both sides with both hands, then withdraw them in front of the chest to form a cross, look forward . Right foot strides horizontally to the right, bend the knee and semi-squat down, straighten the left knee and left leg to form a right bow stance; right hand hold the pen and bend the elbow, pull it to the right till the front of the right shoulder, the center of palm faces inward, the tip of the pen points diagonally upward. At the same time, erect the left palm and push it to the front left. Look to the upper left (Fig. 1).

要求：弓步，一腿屈膝半蹲，大腿接近水平，另一腿挺膝伸直，腳尖內扣，兩腳全腳著地。拉弓勢動作要舒展，兩臂斜直。

Requirements: Bow stance, bend and semi-squat one leg, bow the thigh to the level, straighten the other leg and knee, with the toes buckled, both feet are on the ground. Stretch in the drawing bow stance, straighten your arms diagonally.

音樂功夫筆

❀ （站似一棵松） 並步上刺
(Stand like a pine tree) Folding stance stabbing upward

❀ 身體立起，右腿收於左腿，兩腿併攏。右手持筆，筆尖向上，由右胸前向上直刺，左掌向下按於體側，掌心向下，目視前方（圖2）.

Body upright, withdraw the right leg to the left leg, both legs stand side by side. Right hand holds the pen, with the tip of pen faces up, stab it straight up from the front of the right chest, press the left palm down to the side of the body, the center of palm faces down, look forward (Fig. 2).

要求：上刺筆，力達筆尖，臂要直，盡量貼近耳朵。

Requirements: stab the pen upward, the force reaches the tip of the pen, straighten the arm, place it close to the ear as possible.

❀ （不動不搖坐如鐘） 跪步胸前持筆
(Unwavering and sit like a bell) Kneeling step holding pen in front of the chest

❀ 右腳後撤半步，腳跟抬起，兩腿屈膝下蹲臀部坐於右腳跟上，成跪步。同時，右手持筆隨身體下蹲屈肘落於胸前，左掌抱於右持筆手，目視前方（圖3）

圖 2

Withdraw the right foot half a step, life the heel, bend the both knees and squat so that the hip sit on the right heel to from a kneeling step. At the same time, right hand hold the pen and squat down while bending the elbow downward to the front of the chest, left palm hold the right hand with the pen, look forward (Fig. 3).

要求：兩手于胸同高，環抱於體前，筆尖向上。

Requirements: both hands are level with the chest, encircle in front of the body, the tip of the pen faces up.

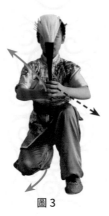

圖 3

✤（走路一陣風）開立步左右擺毛
(Walk with gust of wind) Spread feet stance swinging the pen to the left and right

✤ 身體立起，右腳向前半步成開立步，右手持毛
隨站立向前方刺出，左掌落於左側成按掌，目
視前方（圖 4-1）。身體不變，右手持毛向右，
向左，再向右，向左橫擺中間，目視前方（圖
4-2）。

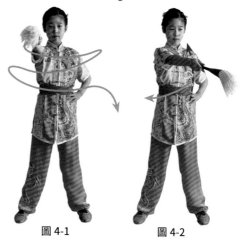

Body upright, right foot steps half forward to form
a spread feet stance, right hand hold the pen and
stab it to the front left while standing upright, left
palm press down to the left side, look forward
(Fig. 4-1). Remain the body unchanged, hold the
pen with the right hand and move it to the right,
and left, and then right, move it to the left and
horizontally place it to the center, look forward
(Fig. 4-1).

圖 4-1 圖 4-2

要求：開立步兩腳間相距略寬於肩。右手直刺，毛於臂成一直線。左右平擺要連貫有韌性。

Requirements: The distance between the feet in the spread feet stance is slightly wider than the
shoulder. The right hand with the pen is stabbed straightly in line with the arm. The left and right
pendulums should be coherent and resilient.

✤（南拳和北腿）左右蹬腳刺毛
(Nanquan and Beitui) Left and right heel kick stabbing pen

✤ 身體重心移向左腿，右腳提起，勾腳尖向前蹬出，力達腳跟；同時右
持毛手屈肘收於右腰間，手心向上，毛尖向前。左掌由腰間向前立掌
推出，目視前方（圖 5-1）．右腳回落成開立步，右手持毛向前刺出，
同時，左手收於左腰間，目視前方（圖 5-2）．身體重心移向右腿，右
持毛手收於右腰間，左掌向前立掌推出，力達掌根，目視前方（圖 5-3）．
隨即左腿提起，勾腳尖向前蹬出，力達腳跟；同時右持毛手由腰間向
前刺出，左掌外旋收於腰間，掌心向上，目視前方（圖 5-4）．左腳回
落成開立步，重心移至兩腿間，右持毛手屈肘收于右腰間，左手由腰
間向前立掌推出，目視前方（圖 5-5）．

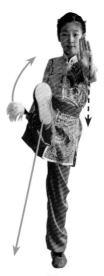

Move the center of gravity to the left leg, lift the right foot, bend the tiptoe
and shape it like a hook, kick it forward, with the force reaches the heel; at
the same time, right hand holds the pen and bend the elbow, withdraw it to
the right waist, the center of hand faces up, the tip of the pen point to the
front. Erect the left palm and push it forward from the side of the waist, look
forward (Fig. 5-1). Right foot falls back to form a spread feet stance, right hand
holds the pen and stab it forward, at the same time, withdraw the left hand

圖 5-1

to the left waist, look forward (Fig. 5-2). Move the center of gravity to the right leg, right hand holds the pen and withdraws it to the right waist, erect the left palm and push it forward, with the force reaches the base of the palm, look forward (Fig. 5-3). Then, lift the left foot, bend the tiptoe and shape it like a hook, kick it forward, with the force reaches the heel; at the same time, right hand holds and pen and stabs it forward from the side of the waist, rotate the left palm externally and withdraw it to the side of the waist, the center of palm faces up, look forward (Fig. 5-4). Left foot falls back to form a spread feet stance, move the center of gravity to the center of both feet, both hands remain unchanged, look forward (Fig. 5-5).

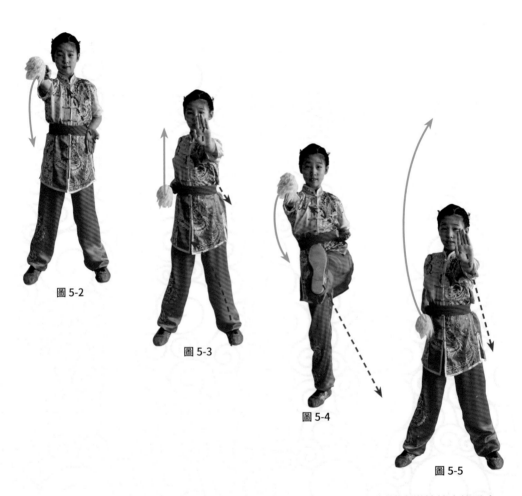

圖 5-2

圖 5-3

圖 5-4

圖 5-5

要求：蹬腿，一腿支撐，另一腿由屈到伸，勾腳尖，力達腳跟；兩腿根據音樂拍節交換蹬出，動作要平穩，協調。隨動作發出哈。

Requirements: Heel kick, support with one leg, straighten the other leg from bent form, bend the tiptoe and shape it like a hook, the force reaches the heel; kick both heels in turns according to the music beat, the movements should be stable and coordinated. Make a sound of 'Ha' along with the movement.

✿（少林武當功）開立步左右輪劈苊

(Shaolin Wudang Kungfu) Spread feet stance left and right hacking pen in turn

✿ 開立步不變，右持苊手由右腰間直臂向上（圖6-1），向左（圖6-2），向後（圖6-3），向前（圖6-4），立圓繞環前劈苊，隨即向上，向右，向後，向上，向前立圓繞環向前劈苊，連續繞環左右各兩次。左手不變，目視前方。

Remain the spread feet stance unchanged, right hand holds the pen and straighten the arm upward from the side of the right waist (Fig. 6-1), move to the left (Fig. 6-2), to the back (Fig, 6-3), to the front (Fig. 6-4), loop and erect a circle at the front and hack the pen, then immediately move upward, to the right, to the back, and upward, loop and erect a circle forward and chop the pen to the front, continuously looping on each side twice. Left hand remains unchanged, look forward.

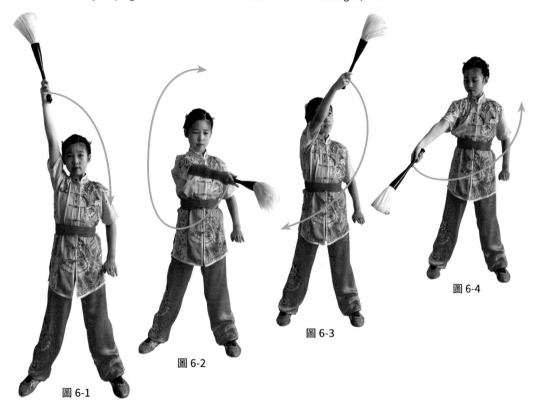

圖 6-4

圖 6-3

圖 6-2

圖 6-1

要求：繞環劈苊，臂於苊需成直線，左右繞環時身體要隨式轉動輪成立圓，目隨式轉動。

Requirements: loop and hack the pen, the arm should be in line with the pen, turn the body along with the movement when circling on the left and right, the eyes should move along with the movement.

✿（太極八卦連環掌）開立步右圈筆
(Tai Chi Bagua Lianhuanzhang) Spread feet stance right circling pen

✿ 開立步不變，右持筆手直臂向左（圖 7-1），向上（圖 7-2），向右（圖 7-3），向下（圖 7-4），立圓繞環三圈至體側。左手不變，目視前方。

Remain the spread feet stance unchanged, right hand hold the pen and straighten the arm to the left (Fig. 7-1), move it upward (Fig. 7-2), to the right (Fig. 7-3), and downward (Fig. 7-4), loop and erect a circle thrice to the side of the body. Left hand remains unchanged, look forward.

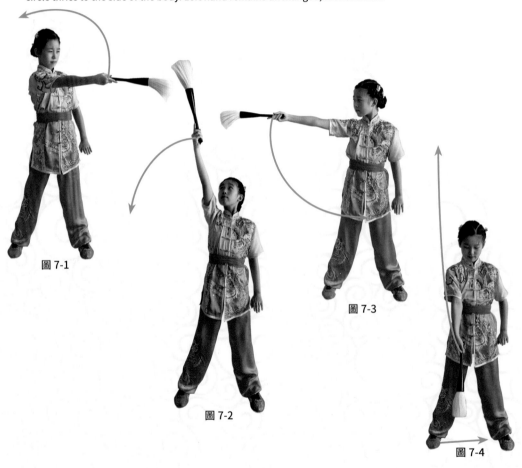

圖 7-1

圖 7-2

圖 7-3

圖 7-4

要求：繞環時筆于臂要直，需立圓繞環。身體隨繞環臂微轉動。

Requirements: The pen and the arm should be straighten when looping, erect the circles when looping. Slightly move the body along with the looping arms.

✿（中華有神功）分腳跳馬步胸前持筆

　（China has magical skills) Spread feet jumping horse step holding pen in front of the chest

✿ 右腿向左腿併攏直立，右持筆手經右胸前向上刺出，力達筆尖。左手不變，目視上方（圖 7-5）。隨即身體跳起，兩腳分開下落成馬步，右持筆手下落胸前，手心向內，筆尖向上，左掌附貼在右手上，目視前方（圖 8）。

Place the right leg closed to the left leg and stand upright, right hand holds the pen and stab it upward through the right chest, the force reaches the tip of the pen. Left hand remains unchanged, look forward (Fig. 7-5).Then, jump up and fall down with both feet separately to form a horse stance, right hand holds the pen and fall down to the front of the chest, the center of hand faces inside, the tip of pen faces up, left palm is attached to the right hand, look forward (Fig. 8).

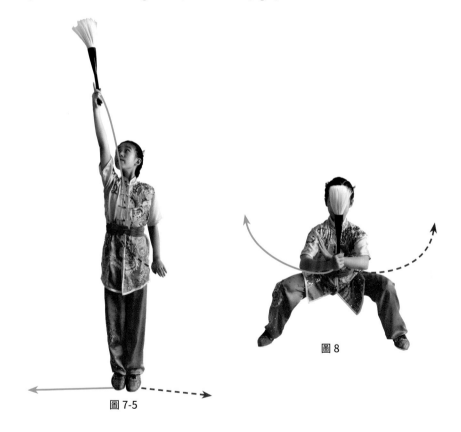

圖 8

圖 7-5

要求：馬步，兩腳相距約本人三腳寬，要挺胸，立腰，跳起不易太高，落地要平穩。整個動作配合音樂需協調一致。

Requirements: Horse stance, two feet should be spacing about three feet in width, chest out, erect waist, do not jump too high, landing stably. The entire movement must be coordinated with the music.

音樂功夫筆

✿ (中華有神功) 右弓步拉弓勢
(China has magical skills) Right bow stance drawing bow stance

✿ 身體立起成開立步，兩手分開（圖9-1），向兩側劃一立圓，胸前交叉，右持筆手在外，左手在內，兩手心都向內，目視前方（圖9-2）。隨即右腿屈半蹲，左腿挺膝伸直成右弓步；右持筆手屈肘向右拉至右肩前，手心朝內，筆尖斜向前上。同時左掌向左前上立掌推出。目視左上方（圖9-3）。

Body upright and form a spread feet stance, separate both hands (Fig. 9-1), erect circles to both sides, cross the hands in front of the chest, with right hand holding the pen outside, left hand inside, both the center of hand face inside, look forward (Fig. 9-2). Then, bend the right leg and semi-squat, straighten the left leg and left knee to form a right bow stance; right hand holds the pen and bend the elbow, pull it to the right till the front of the right shoulder, the center of hand faces inward, the tip of the pen points diagonally upward. At the same time, erect the left palm and push it to the front left. Look to the upper left (Fig. 9-3).

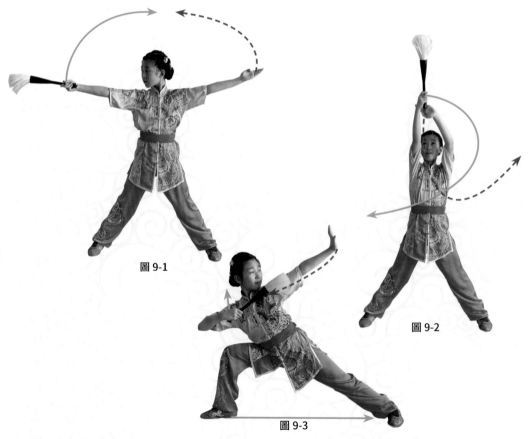

圖 9-1

圖 9-2

圖 9-3

要求：從這個動作開始（除起勢、收勢外）配合音樂完成套路做三遍

Requirements: Same as before.

✪ 重複（中華有神功）收筆

Repeat (China has magical skills) Put away the pen

✪ 兩腿直立，兩腳併攏，雙手托筆于胸前（圖 10-1）。雙手持筆不變，彎腰 90 度敬禮（圖 10-2）。身體立直，變右手持筆，筆尖向上，左手變掌立於右手側，成持筆抱拳敬禮（圖 10-3）。

Stand upright with both legs and two feet stand side by side, hold the pen with both hands in front of the chest (Fig. 10-1). Remain both hands holding the pen unchanged, bow over 90 degrees to salute (Fig. 10-2). Body upright, right hand holds the pen, with the tip of the pen points upward, change the left hand to a palm and erect it to the side of the right hand, hold pen and salute with fist. (Fig. 10-3).

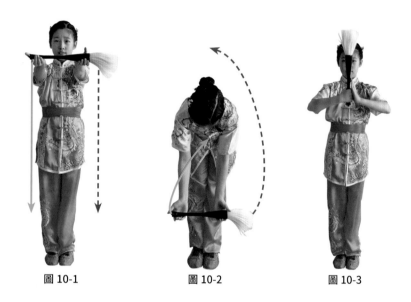

圖 10-1　　　　　　圖 10-2　　　　　　圖 10-3

要求：神態恭謹，氣勢宏博。

Requirements: Respectful and imposing.

抱拳禮（弟子規）

Salute with fist (the rules for students)

左手掌，右手拳，將拳面放在左掌心，兩臂環抱胸前，高於胸平。(圖1)

Left hand with palm, right hand with fist, attach the face of fist to the center of palm, encircle both arms in front of the chest, place them higher than the chest level. (Fig. 1)

預備式（哈）"總敘"

Ready posture (Ha) "General preface"

左腳向左橫邁一步，略寬于肩，成開立步。兩手握拳收抱腰間。(圖2)

Left foot step to the left horizontally, slightly wider than the shoulder, form a spread feet stance. Withdraw both hands with fists to the sides of the waist. (Fig. 2)

要求：挺胸立腰，目視正前方。

Requirements: Chest out and erect waist, look forward.

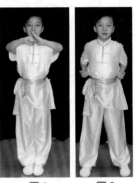

圖1　　　圖2

1. 右衝拳（弟子規）

Right punching fist ("The Rules for Students")

右拳從腰間旋臂向前擊出，力達拳面，高于鼻平，拳背向上。(圖3)

Rotate the arm and punch the right fist forward from the side of the waist, the force reaches the face of the fist, level with the nose, the back of the fist faces up. (Fig. 3)

2. 左衝拳（聖人訓）Left punching fist (Are the Sage's teachings)

左拳從腰間旋臂向前擊出，力達拳面，高于鼻平，拳背向上。同時右拳收抱腰間。(圖4)

Rotate the arm and punch the left fist forward from the side of the waist, the force reaches the face of the fist, level with the nose, the back of the fist faces up. At the same time, withdraw the right fist to the side of the waist. (Fig. 4)

3. 右衝拳（弟子規）同前1(圖3)

Right punching fist ("The Rules for Students") Same as step 1 (Fig. 3)

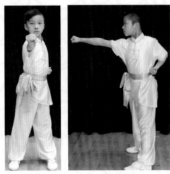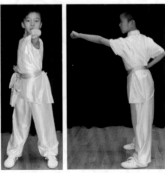

圖3　　　圖3側面　　　圖4　　　圖4側面

4. 左衝拳（聖人訓）同前 2（圖 4）

Left punching fist (Are the Sage's teachings) Same as step 2 (Fig. 4)

5. 連衝三拳（哈，哈，哈）

Continuously punching three fists (Ha, ha ha)

動作于前兩動相同。（如圖 3-4）

Same as the previous two movements. (Like fig. 3-4)

要求：動作連貫，出拳時需轉腰，順肩，力達拳面。發聲要配合動作。

Requirements: The movements should be coherent, punching the fist requires turning the waist, and moving along with the shoulders, the force reaches the face of fist. Cooperate with the movement when making sound.

6. 左推掌（首孝悌）

Left pushing palm (First be good to parents and respect elders)

左掌從腰間旋臂向前推出，力達掌根。掌指于眉相高，眼平視前方。（圖 5）

Rotate the arm and push the left palm forward from the side of the waist, the force reaches the base of the palm, fingertips are level with the eye, look straight ahead. (Fig. 5)

7. 右推掌（次謹信）

Right pushing palm (Next be reverent and trustworthy)

右掌從腰間旋臂向前推出，力達掌根。掌指于眉相高，眼平視前方。同時左掌收于腰間。（圖 6）

Rotate the arm and push the right palm forward from the side of the waist, the force reaches the base of the palm, fingertips are level with the eye, look straight ahead. At the same time, withdraw the left palm to the side of the waist. (Fig. 6)

8. 左推掌（首孝悌）同前 6（圖 5）

Left pushing palm (First be good to parents and respect elders)Same as step 6 (Fig. 5)

9. 右推掌（次謹信）同前 7（圖 6）

Right pushing palm (Next be reverent and trustworthy)Same as step 7 (Fig. 6)

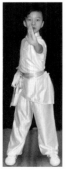 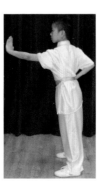 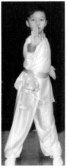 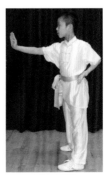

圖 5 圖 5 側面 圖 6 圖 6 側面

10. 連推三掌（哈，哈，哈）
Continuously pushing three palms (Ha, ha, ha)

動作于前左，右推掌相同。（如圖 5-6）

Same as the previous two movements, left and right pushing palm. (Like fig. 5-6)

要求：動作連貫，協調，推掌有力，掌成立掌，力達掌根。發聲于動作緊密配合。

Requirements: The movements should be coherent and coordinated, push the palms forcefully, erect the palms, the force reaches the base of palms. Closely coordinate with the movement when making sound.

11. 右掄劈拳（泛愛眾）
Right straight-arm hacking fist (Love everyone)

右拳由體前從左向上向右側掄劈，拳于肩平，力達拳輪。同時甩頭向右看。（圖 7）

Straighten the arm and hack the right fist in the front of the body from left to the top and to the right, the fist is level with the shoulder, with the force reaches the curve of the fist. At the same time, swing the head and look to the right. (Fig. 7)

12. 左掄劈拳（而親仁）
Left straight-arm hacking fist (And become close with the kind-hearted)

左拳由體前從右向上向左側掄劈，拳于肩平，力達拳輪。甩頭向左看；同時右拳收抱腰間。（圖 8）

Straighten the arm and hack the left fist in the front of the body from right to the top and to the left, the fist is level with the shoulder, with the force reaches the curve of the fist. Swing the head and look to the left; at the same time, withdraw the right fist to the side of the waist. (Fig. 8)

13. 右掄劈拳（泛愛眾）同前 11 動作（如圖 7）
Right straight-arm hacking fist (Love everyone) Same as step 11 (Fig. 7)

14. 左掄劈拳（而親仁）同前 12 動作（如圖 8）
Left straight-arm hacking fist (And become close with the kind-hearted) Same as step 12 (Fig. 8)

要求：左右臂掄成立圓，劈拳于甩頭同時進行。要挺胸立腰，不可前俯後仰。

Requirements: Erect an circle when hacking with left and right arm, hack the fist and swing the head at the same time. Chest out and erect waist, do not lean forward or backward.

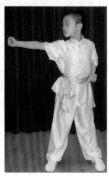 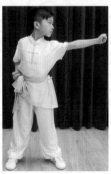

圖 7　　　　　　圖 8

15. 左勾手亮掌（有余力）

Left hook hand flashing palm (If there's energy left over)

甩頭向前看；左拳變勾手向後擺，同時右拳變掌向右，向上抖腕亮掌，架于頭上方。甩頭向左看。(圖 9)

Swing the head and look forward; change the left fist to a hook hand and sway backward, at the same time, change the right fist to a palm, tremble the wrist to the right and to the top, flash the palm, block it over the head. Swing the head and look to the left. (Fig. 9)

16. 右勾手亮掌（則學文）

Right hook hand flashing palm (Then study books)

左手變掌由右後向左側向上抖腕亮掌，架于頭頂上方；同時右手向右向後變勾手于體後方。甩頭向右看。(圖 10)

Change the left hand to a palm, tremble the wrist from the back to the left and to the top, flash the palm, block it over the head; at the same time, sway the right hand to the right and to the back, change it to a hook hand and place it at the back of the body. Swing the head and look to the right. (Fig. 10)

17. 左勾手亮掌（有余力）同 15 動作（如圖 9）

Left hook hand flashing palm (If there's energy left over) Same as step 15 (Like fig. 9)

18. 右勾手亮掌（則學文）同 16 動作（如圖 10）

Right hook hand flashing palm (Then study books) Same as step 16 (Like fig. 10)

要求：勾手，亮掌，甩頭要同時進行；勾手臂要直，不可彎曲，勾尖向上。

Requirements: Form the hook hand, flash the palm, and swing the head at the same time; straighten the arm of the hook hand, do not bend it, the tip of the hook faces up.

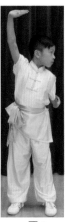 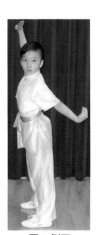 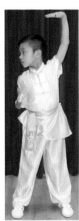

圖 9 圖 9 側面 圖 10 圖 10 側面

起式：
Starting form：

1. 提膝舉拳（入則孝）
Lift knee lift fist (Be good to parents inside the family)
右手變拳經前向上舉起，拳心向前；左掌向左側平舉；同時右腿屈膝提起成獨立步舉拳，目視前方。（圖 11）
Change the right hand to a fist, lift it up in front of the body, the center of fist face forward; lift the left palm to the left till the level; at the same time, bend and lift the right knee to form a single leg stance with lifting fist, look forward. (Fig. 11)

2. 震腳砸拳（哈）Stamp foot hammer strike (Ha)
兩腿屈膝半蹲，兩腳下跺震地；同時兩手下落于胸前，右手背擊打左掌心成砸拳。眼平視前方。（圖 12）
Bend both knees and semi-squat, stomp and stamp both feet; at the same time, drop both hands to the front of the chest, the back of right hand hits the center of left palm to form a hammer strike. Look straight ahead. (Fig. 12)

要求：提膝舉拳需臂直貼近耳朵，支撐腿直立，提膝腳腳尖下垂，貼于左腿；震腳砸拳需動作連貫協調一致，震腳于砸拳同時進行。半蹲要挺胸立腰。
Requirements: The arm should be close to the ear in lift knee lift fist movement, erect and straighten the supporting leg, the tiptoes of the foot lifted should point downward, and attached to the left leg; the stamp foot hammer strike movement should be consistent and coordinated, stamp foot and form the hammer strike at the same time. Chest out and erect waist in semi-squat.

第一段 Segment one

1. 左順弓步沖拳（父母呼）
Left bow stance punching fist (When parents call)
左腳向左邁步成左弓步；同時左手向左沖拳，成左順弓步沖拳。（圖 13）
Left foot step to the left and form a bow stance; at the same time, left hand punch fist to the left, form a left bow stance punching fist. (Fig. 13)

2. 右順弓步沖拳（應勿緩）
Right bow stance punching fist (Do not be slow to answer)
右腳經左腳內側向前上一大步成右弓步；左拳收于腰間，右拳隨上步向前伸出，成右弓步沖拳。（圖 14）
Right foot takes a big step forward through the inside of the left foot to form a right bow stance; withdraw the left fist to the side of the waist, right fist stretches forward when stepping forward, form a right bow stance punching fist.

要求：弓步前腳微內扣，大腿接近水平，後腿挺膝伸直，腳尖內扣。挺胸立腰，沖拳有力，力達拳面，眼平視前方。

Requirements: In the bow stance, slightly buckle the forefoot inward, the thigh should be close to the level, straighten the rear leg, buckle the tiptoes inward. Chest out and erect waist, punch the fist with force, and the force should reach the face of the fist, look straight ahead.

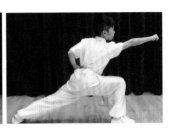

圖 11　　　　　圖 12　　　　　圖 13　　　　　圖 14

3. 提膝震腳砸拳（父母命）

Lift knee stamp foot hammer strike (When parents give an order)

(1) 身體直立，右腿提起，右拳上舉，拳心向前；左拳變掌向左側平舉，眼視前方。（圖 15-1）

Body upright, lift the right leg, lift the right fist, the center of the fist face forward; change the left fist to a palm and lift it to the left till the level, look forward. (Fig. 15-1)

(2) 兩腿屈膝半蹲，兩腳下跺震地；同時兩手下落胸前，右拳擊打左手心成砸拳。（圖 15-2）

Bend both knees and semi-squat, stomp and stamp both feet; at the same time, drop both hands to the front of the chest, right fist hits the center of left hand to form a hammer strike. (Fig. 15-2)

要求：動作連貫，有節奏，雖然分兩小節，但要一氣呵成，提膝舉拳時呼（父母）砸拳時呼（命）半蹲動作要挺胸立腰，不可低頭俯腰。

Requirements: The movement should be coherent and rhythmic. Although it is divided into two bars, it should be done in one go. Exhale (parents) when lift knee lift fist, exhale (order) when hammer strike. In semi-squat movement, chest out and erect waist, do not bow the head or bend down.

4. 轉身跳馬步架沖拳（行勿懶）

Jump and turn the body with horse stance blocking punch fist (Do not be lazy)

兩腳登地跳起身體右轉 180° 成馬步；同時，右拳變掌架于頭頂上方，左手向左沖拳。眼視左方。（圖 16）

Both feet jump off the ground and turn the body 180 degrees to the right to form a horse stance; at the same time, change the right fist to a palm and block it over the head, punch the left hand to the left. Look to the left. (Fig. 16)

要求：整個動作連貫協調，需一氣呵成。馬步兩腳正直前方，寬約三腳半，右大腿屈蹲接近水平。挺胸立腰。

Requirements: The entire movement should be coherent and coordinated, and needs to be done in one go. Both feet point forward in horse step, with about three and a half feet wide, squat the right thigh close to the level. Chest out and erect waist.

5. 弓步雙擺掌（父母教）

Bow stance swaying palms (When parents teach)

身體右轉成右弓步；同時兩手變掌向上向右平擺掌，左掌附于右肘內側。眼平視右前方。（圖 17）

Turn right and form a right bow stance; at the same time, change both hands to palms and sway them upward and to the right, attach the left palm to the inside of the right elbow. Look to the front tight.

要求：身體右轉成弓步于雙擺掌同時進行。

Requirements: Turn right to form a bow stance and sway both palms at the same time.

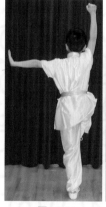 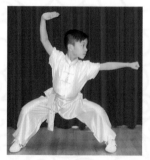 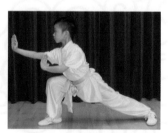

圖 15-1　　　圖 15-2　　　　　圖 16　　　　　　　圖 17

6. 左弓步撩掌（須敬听）Left bow stance arc palm (One must listen respectfully)

身體左轉成左弓步；同時，左手向下，隨轉身向前向後勾手，右掌向下隨轉身向前撩掌，手心朝上。眼平視前方。（圖 18）

Turn left to form a left bow stance; at the same time, move the left hand downward, form a hook hand forward to backward when turning the body, move the right palm downward and arc the palm forward when turning the body, the center of palm faces up. Look straight ahead. (Fig. 18)

要求：轉身要迅速靈活，撩掌于肩同高勾手儘量上翹，兩臂要直。

Requirements: Turn the body quickly and flexibly, the arc palm is level with the shoulder, cock the hook hand as much as possible, straighten both arms.

7. 彈腿推掌（父母責）Flip leg pushing palm (When parents reprimand)

身體稍直立，右腿提起由屈到伸，向前彈出，腳面繃平；同時右掌變拳收抱腰間，左勾手變掌由腰間立掌向前推出。（圖 19）

Body slightly upright, the right leg is lifted from bent to extended, flip it forward, the instep is tightly flattened; at the same time, change the right palm to a fist and withdraw it to the side of the waist, change the left hook hand to a palm and push it forward from the side of the waist.

要求：彈腿要由屈到伸彈擊，力達腳尖，推掌立掌，力達掌根。

Requirements: Flip kick the leg from bent to extended, the force reaches the tiptoes, push and erect the palm, the force reaches the base of the palm.

8. 右弓步架沖拳（應順承）Right bow stance blocking punch fist (One must accept)

右腳向前落步成弓步；同時左手向上架于頭頂上方，右拳向前沖出，眼平視前方。（圖 20）

Drop the right foot forward to form a bow stance; at the same time, block the left hand over the head, punch the right fist forward, look straight ahead. (Fig. 20)

要求：落步要輕靈，弓步立腰，上體不可過于前傾，左架掌需撐圓，沖拳要立達拳面。

Requirements: Flip kick the leg from bent to extended, the force reaches the tiptoes, push and erect the palm, the force reaches the base of the palm.

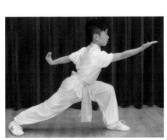
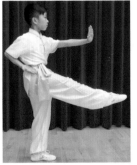
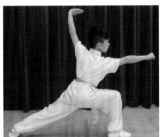

圖 18　　　　　　　圖 19　　　　　　　圖 20

第二段 Segment two

9. 轉身震腳砸拳 (冬則溫)

Turn the body with stamping feet hammer strike (In winter keep warm)

(1) 轉身提膝舉拳。身體直立左轉 , 右腿屈膝提起 ; 同時右拳向上舉起 , 拳心向前 , 左手平舉體側。眼平視前方。(圖 21-1)

1)Turn the body and lift knee lift fist. Body upright and turn to the left, bend and lift the right knee; at the same time, lift the right fist, the center of fist face forward, horizontally lift the left hand to the level beside the body. Look straight ahead. (Fig. 21-1)

(2) 半蹲震腳砸拳。兩腿屈膝半蹲 , 兩腳下跺震地 ; 同時兩手下落于胸前 , 右手背擊打左掌心成砸拳。眼平視前方。(圖 21-2)

(2) Semi-squat stamping feet hammer strike. Bend both knees and semi-squat, stomp and stamp both feet; at the same time, drop both hands to the front of the chest, the back of right hand hits the center of left palm to form a hammer strike. Look straight ahead. (Fig. 21-2)

要求 : 冬則－提膝舉拳－溫－半蹲砸拳 , 要連貫并有節奏。砸拳需立腰 , 脆快 , 響亮。

Requirements: In winter － lift knee lift fist － keep warm － semi-squat hammer strike, the movement should be coherent and rhythmic. Erect waist, with alacrity, loud and clear in hammer strike.

10. 并步挑掌 (夏則清) Folding stance snapping palm (In summer keep cool)

身體立直 , 左手向前挑掌 , 右拳收于腰間。眼平視前方。(圖 22)

Body upright, snap the left palm forward, withdraw the right fist to the side of the waist. Look straight ahead. (Fig. 22)

要求 : 身體立直 , 挺胸塌腰 , 挑掌需從下向上抖腕挑起。

Requirements: Body upright, chest out and sink waist, tremble the wrist from the bottom to the top when snapping the palm.

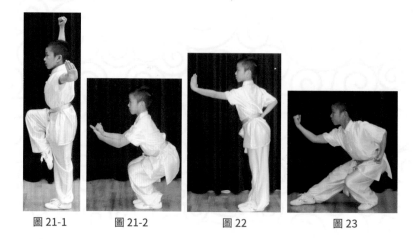

圖 21-1 圖 21-2 圖 22 圖 23

11. 虛步格肘（晨則省）Empty stance blocking with bending elbow

左腳稍外展，屈膝半蹲，右腿微屈腳面繃直，腳尖虛點地面成虛步；同時左掌變拳收于腰間，右肘稍屈，向前橫格，拳心向里，眼視前方。（圖 23）

Slightly outstretch the left leg, bend the knee and semi-squat, slightly bend the right leg and tightly straighten the instep, the tiptoes touch the ground with false step to form an empty stance; at the same time, change the left palm to a fist and withdraw it to the side of the waist, slightly bend the right elbow, block it forward, the center of fist face inside, look forward. (Fig. 23)

要求：虛步屈蹲儘量接近水平，上體不可過於前傾或左右歪斜。格肘力點在前小臂。

Requirements: The empty stance with squat should be as close to the level as possible, the upper body should not be too forward or skewed from side to side. The force of blocking elbow is on the forearm.

12. 右弓步沖拳馬步沖拳（昏則定）

Right bow stance punching fist and horse stance punching fist (In the evening settle down)

(1) 右腳向前邁步成弓步；同時左拳隨弓步向前旋臂擊出，右拳收于腰間。眼視前方。（圖 24-1）

(1) Right foot step forward to form a bow stance; at the same time, rotate the left arm and punch the left fist forward when forming the bow stance, withdraw the right fist to the side of the waist. Look forward. (Fig. 24-1)

(2) 身體左轉成馬步，左拳收于腰間，右拳隨轉身向右側擊出（沖拳）。眼視右前方。（圖 24-2）

(2) Turn left to form a horse stance, withdraw the left fist to the side of the waist, punch the right fist to the right when turning the body. Look to the front right. (Fig. 24-2)

要求：整個動作連貫，協調，轉換要靈活。

Requirements: The whole movement should be coherent, coordinated, and the conversion should be flexible.

13. 虛步格肘（出必告）

Empty stance blocking with bending elbow (When leaving one must tell one's parents)

身體右轉右腳稍外展，屈膝半蹲，左腿微屈，腳面繃直，腳尖虛點地面成虛步；同時隨轉身右手收于腰間。左手肘稍屈，向左前橫格，拳心向里，眼視前方。（圖 25）

Turn right and slightly outstretch the right foot, bend the knee and semi-squat, slightly bend the left leg, tightly straighten the instep, the tiptoes touch the ground with false step to form an empty stance; at the same time withdraw the right hand to the side of the waist when turning the body. Slightly bend the left elbow, block it to the front left, the center of fist face inside, look forward. (Fig. 25)

要求：虛步屈蹲儘量接近水平，上體不可過於前傾或左右歪斜。格肘力點在前小臂。

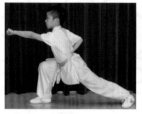
圖 24-1

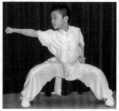
圖 24-2

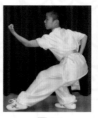
圖 25

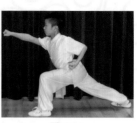
圖 26-1

Requirements: The empty stance with squat should be as close to the level as possible, the upper body should not be too forward or skewed from side to side. The force of blocking elbow is on the forearm.

14. 左弓步沖拳馬步沖拳 (反必面)

Left bow stance punching fist and horse stance punching fist (Upon returning one must see one's parents face-to-face)

(3) 左腳向前邁步成弓步；同時右拳隨弓步向前旋臂擊出，左拳收于腰間。眼視前方。(圖 26-1)

(3) Left foot step forward to form a bow stance; at the same time, rotate the right arm and punch the right fist forward when forming the bow stance, withdraw the left fist to the side of the waist. Look forward. (Fig. 26-1)

(2) 身體右轉成馬步，右拳收于腰間，左拳隨轉身向左側擊出 (沖拳)。眼視左前方。(圖 26-2)

(2) Turn right to form a horse stance, withdraw the right fist to the side of the waist, punch the left fist to the left when turning the body. Look to the front left. (Fig. 26-2)

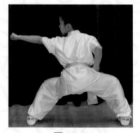
圖 26-2

要求：整個動作連貫，協調，轉換要靈活。

Requirements: The whole movement should be coherent, coordinated, and the conversion should be flexible.

15. 分手勾踢 (居有常)(2) Separate hands kicking with cocked foot (There should be regularity in one's daily life)

(1) 身體左轉，左腳外展，兩腿稍屈，成交叉步；同時兩手變掌，右手向上向前搭在左掌上，兩手交叉。(圖 27-1)

(1) Turn left, outstretch the left foot, slightly bend both legs, form a cross step; at the same time, change both hands to palms, attach the right hand to the left palm from the top to the front, cross both hands. (Fig. 27-1)

(2) 右手向右後側摟手變勾手，左手向左上分手架于頭頂上方成亮掌；同時右腳勾起向左前勾踢。眼視前方。(圖 27-2)

(2) Right hand forms a grabbing hand to the back right and change it to a hook hand, separate the left hand at the upper left, block it over the head and form a flash palm; at the same time, cock the right foot and kicking it to the front left with cocked foot. Look forward. (Fig. 27-2)

要求：整個動作需一氣呵成。摟手和勾踢應同時進行。勾踢腳跟可擦地。

Requirements: The whole movement should be done in one go. Grabbing hands and kicking with cocked foot should be done at the same time. The heel of the kicking with cocked foot can wipe the floor.

16. 小纏馬步橫打（業無變）

Wrapping horse stance horizontal punch (And no change in one's career)

(1) 身體微向右轉，兩掌在體前相擊，左手擊抓右腕，然後右手向外旋撐；同時右腳外展。（圖 28-1）

(1) Slightly turn right, clap both palms in front of the body, left hand hit and grasp the right wrist, then twist the right hand outward; at the same time, outstretch the right foot. (Fig. 28-1)　(2) 兩手帶于腹前，右腳下跺震地，左腳提起向左側滑步成馬步，左手變拳向左側平擺橫擊，右拳收于腰間，眼向左平視。（圖 28-2）

(2) Bring both hands in front of the belly, stomp and stamp the right foot, lift the left foot and side to the left to form a horse stance, change the left hand to a fist and horizontally sway it to the left and punch, withdraw the right fist to the side of the waist, horizontally look to the left. (Fig. 28-2)

要求：整個動作連貫圓活，"小纏"實是纏腕動作，使右手外旋手心向上；馬步橫擊拳背向上，力達拳輪。

Requirements: The whole movements should be coherent, "wrapping" is a wrist-wrapping movement which makes the right hand externally rotated with the center of palm facing upward; the back of the fist faces up in the horse stance horizontal punch, the force reaches the curve of the fist.

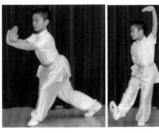 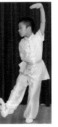 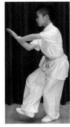 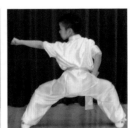

圖 27-1　　圖 27-2　　圖 28-1　　圖 28-2

第三段 Segment three:

17. 撤步右弓步下格打（事雖小）

Backward moving step right bow stance blocking (Though a matter may be small)

身體稍左轉，左腳向後撤一大步成右弓步，同時左拳收于腰間，右拳向前下格打，臂微屈，拳于膝高拳心向下，眼視下方。（圖 29）

Slightly turn left, left foot takes a big step backward to form a right bow stance, at the same time, withdraw the left fist to the side of the waist, block the right fist to the lower front, slightly bend the arm, the fist is level with the knee, the center of fist faces down, look down. (Fig. 29)

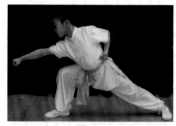

圖 29

要求：撤步要迅速，右臂格打力達前小臂，拳心向下。

Requirements: The backward moving step should be done quickly, the force of the right arm blocking reaches the forearm, the center of fist faces down.

18. 右弓步上格打（勿擅為）Right bow stance upper blocking (Don't act arbitrarily)

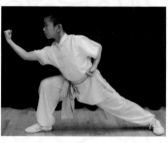

圖 30

步型不變，右拳由下向上反格打。眼視右拳。（圖 30）

Remain the step unchanged, right fist reverse blocking from the bottom to the top. Look at the right fist. (Fig. 30)

要求：右拳由右向上反格打，力達右前臂外側。

Requirements: Right fist reverse blocking from the right to the top, the force reaches the outside of the right forearm.

19. 撤步左弓步下格打（苟擅為）

Backward moving step left bow stance lower blocking (If one acts arbitrarily)

右腳向後撤一大步成左弓步，同時右拳收于腰間，左拳向前下格打，臂微屈，拳于膝高拳心向下，眼視下方。（圖 31）

Right foot takes a big step backward to form a left bow stance, at the same time, withdraw the right fist to the side of the waist, block the left fist to the lower front, slightly bend the arm, the fist is level with the knee, the center of fist faces down, look down. (Fig. 31)

要求：撤步要迅速，左臂格打力達前小臂。

Requirements: The backward moving step should be done quickly, the force of the left arm blocking reaches the forearm.

20. 左弓步上格打（子道虧）

Left bow stance upper blocking (the code that a son ought to follow gets damaged)

步型不變，左拳由下向上反格打。眼視左拳。（圖 32）

Remain the step unchanged, left fist reverse blocking from the bottom to the top. Look at the left fist. (Fig. 32)

要求：左拳由右向上反格打，力達左前臂外側。

Requirements: Left fist reverse blocking from the right to the top, the force reaches the outside of the left forearm.

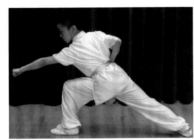 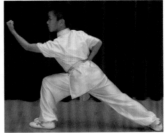

圖 31 圖 32

21. 撤步馬步砍掌（物雖小）

Backward moving step horse stance chopping palm(Though a thing may be small)

左腳向後撤一步隨之身體左轉成弓步。同時左手收于腰間；右拳變掌向上砍掌，掌心向上。眼視右手。（圖 33）

Left foot step backward and turn left to form a bow stance. At the same time, withdraw the left fist to the side of the waist, change the right fist to a palm and chop the palm upward, with the center of palm facing upward. Look at the right hand. (Fig. 33)

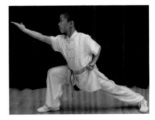

圖 33

要求：撤步轉身要迅速，砍掌指尖于頭高，力達掌外緣。

Requirements: The backward moving step with turning the body should be done quickly, the fingertips of the chopping palm are level with the head, with the force reaches the outer edge of the palm.

22. 馬步摟勾亮掌（勿私藏）Horse stance grabbing hook (Don't selfishly hoard it)

右腳內扣，兩腿屈膝成馬步，右掌內旋向下，向後摟勾，同時左手架于頭頂上方成亮掌，眼視右側方。（圖 34）

Buckle the right foot, bend both knees to form a horse stance, rotate the right palm inwards, grab a hook downward and backward, at the same time, block the left hand over the head to form a flash palm, look to the right. (Fig. 34)

要求：摟勾要明顯，先摟手，到體後再勾手，左手抖腕架于頭頂上方成亮掌。

Requirements: The grabbing hook should be obvious. First, form a grabbing hand, and then form a hook hand after it reaches the body. Tremble the left wrist and block the left hand over the head to form a flash palm.

23. 撤步馬步砍掌（苟私藏）

Backward moving step with horse stance chopping palm (If one selfishly hoards)

身體右轉，右腳向後撤步成弓步。同時右手變拳收于腰間；左掌隨轉身向上砍掌，掌心向上。眼視左手。（圖35）

Turn right, right foot step backward to form a horse stance. At the same time, change the right hand to a fist and withdraw it to the side of the waist; chop the left palm upward when turning the body, the center of palm faces up, look at the left hand. (Fig. 35)

要求：撤步轉身要迅速，砍掌指尖于頭高，力達掌外沿。

Requirements: The backward moving step with turning the body should be done quickly, the fingertips of the chopping palm are level with the head, with the force reaches the outer edge of the palm.

24. 馬步摟勾（親心傷）Horse stance grabbing hook (The parents' hearts will be hurt)

左腳內扣，兩腿屈膝成馬步，左掌內旋向下，向後摟勾，右手架于頭頂上方成亮掌，眼視左側方。（圖36）

Buckle the left foot, bend both knees to form a horse stance, rotate the left palm inwards, grab a hook downward and backward, at the same time, block the right hand over the head to form a flash palm, look to the left. (Fig. 36)

要求：摟勾要明顯，先摟手，到體後再勾手，右手抖腕架于頭頂上方成亮掌。

Requirements: The grabbing hook should be obvious. First, form a grabbing hand, and then form a hook hand after it reaches the body. Tremble the right wrist and block the left hand over the head to form a flash palm.

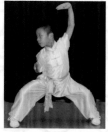
圖 34

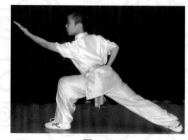
圖 35

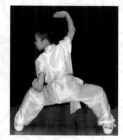
圖 36

第四段 Segment four

25. 左弓步沖拳（親所好）Left bow stance punching fist (What parents like)

左腳向前進步成左弓步，右掌變拳下落腰間，然後向前沖出；左勾手變拳收于腰間。眼視前方。(圖 37)

Left foot step forward to form a left bow stance, change the right palm to a fist and drop it to the side of the waist, then punch it forward; change the left hook hand to a fist and withdraw it to the side of the waist. Look forward. (Fig. 37)

要求：馬步轉換弓步時前腳可向前進一小步。拳從腰間向前旋臂擊出，力達拳面。

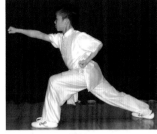

圖 37

Requirements: The forefoot can take a small step forward when changing the horse stance to a bow stance. Rotate the arm and punch the fist forward from the side of the waist, with the force reaches the face of fist.

26. 虛步挑掌（力為具）Empty stance snapping palm

身體重心後移，右腿屈膝半蹲，左腿稍屈，腳尖虛點地面成虛步；同時左拳變掌向前穿出挑掌，右拳收于腰間。眼視前方。(圖 38)

Move the center of gravity backward, bend the right knee and semi-squat, slightly bend the left leg, the tiptoes touch the ground with false step to form an empty stance; at the same time, change the left fist to a palm and pierce it forward, forming a snapping palm, withdraw the right fist to the side of the waist. Look forward. (Fig. 38)

要求：虛步屈蹲腿儘量接近水平。上體不可過于前傾和左右歪斜。

Requirements: The empty stance with squat should be as close to the level as possible, the upper body should not be too forward or skewed from side to side.

27. 托掌震腳弓步雙推掌（親所惡）Holding palms stamp foot bow stance pushing palms

(1) 身體重心前移至左腿，右腳提起，右拳變掌向前伸出，兩掌心向上托掌。(圖 39-1)

(1) Move the center of gravity forward to the left leg, lift the right leg, change the right fist to a palm and stretch it forward, the center both of palms face up with holding palms. (Fig. 39-1)

(2) 右腳下落震地，左腳提起；同時兩掌內旋下按至體側，掌心向下。眼視前方。(圖 39-2)

(2) Drop and stamp the right foot, lift the left leg; at the same time, rotate both palms inwards and press them downward to the sides of the body, the center of palms face down. Look forward. (Fig. 39-2)

(3) 左腳向前一步成左弓步，兩掌向前推出。眼視前方。(圖 39-3)

(3) Left foot step forward to form a left bow stance, push both palms forward. Look forward. (Fig. 39-3)

要求：整個動作連貫協調，需要一氣呵成。重心前移于托掌同時進行，托掌兩臂可稍屈；震腳于按掌同時進行，按掌時手心朝下；弓步于推掌同時進行，力達兩掌根。

Requirements: The whole movement should be coherent and coordinated, and needs to be done in one go. Move the center of gravity forward and form the holding palms at the same time, the arms of the holding palms can be slightly bent; stamp the foot and press the palms at the same time, the center of palms face down when pressing the palms; form the bow stance and pushing palms at the same time, the force reaches the base of the palms.

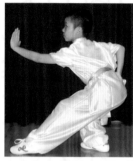 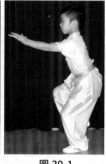 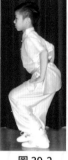 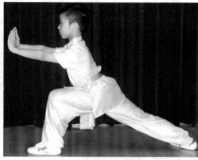

圖 38　　　　　　圖 39-1　　　　圖 39-2　　　　　　圖 39-3

28. 分手勾踢 (謹為去) Separate hands kicking with cocked foot (Carefully get rid of)

兩掌先交叉，左手在內，右手在外，兩手同時向下經身體兩側向後勾手；同時右腿提起由屈到伸向前彈出，力達腳尖。眼視前方。(圖 40)

Cross the palms, with left hand inside, right hand outside, move both hands downward simultaneously through the sides of the body and form hook hands at the back; at the same time, lift the right leg from bent to extended, flip the leg forward, the force reaches the tiptoes. Look forward. (Fig. 40)

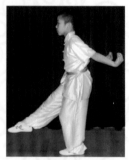

圖 40

要求：兩掌分手于彈踢同時進行。支撐腿可稍屈。

Requirements: Separate both palms and flip kick at the same time. The supporting leg can be slightly bent.

29. 并步上擊掌 (身有傷) Folding stance upper clapping palms

右腳向前落步，左腳向右腳并攏，身體直立；同時兩勾手變掌經體側向上擊掌。眼視前方。(圖 41)

要求：身體直立需挺拔。兩臂在頭頂上方撐圓，左手擊拍右手背做響。

Drop the right foot forward, with the left and right foot standing side by side, upright the body; at the same time, change both hook hands to palms and clap the palms at the top through the sides of the body. Look forward. (Fig. 41)

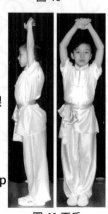

圖 41 正反

30. 弓步劈拳（貽親慚）Bow stance hacking fist (Brings parents shame)

右腳向前進一大步成弓步；同時右手變拳直臂向前下劈擊，拳眼向上；左手變拳收于腰間。眼視前方。（圖 42）

Right foot takes a big step forward to form a bow stance; at the same time; change the right hand to a fist and hack it to the lower front with the arms straightened, the eye of fist faces up; change the left hand to a fist and withdraw it to the side of the waist. Look forward. (Fig. 42)

要求：劈拳力達拳輪。

Requirements: The force of hacking fist reaches the curve of the fist

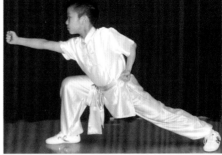

圖 42

31. 撩拳擊拍（德有傷）arc fist hitting (Injury to one's character)

身體左轉成左弓步；右拳隨轉身向下經右側向前向上撩拳，待于胸平時擊拍左掌。眼平視前方。（圖 43）

Turn left to form a left bow stance; move the right fist downward when turning the body, and arc the fist forward and upward through the right-hand side, hit the left palm with the fist when it reaches the same level with the chest. Look straight ahead. (Fig. 43)

要求：由右弓步轉變左弓步要靈活。隨轉身左手伸向前迎擊右拳面，作響。兩臂微屈。

Requirements: Be flexible when changing the right bow stance to a left bow stance. Stretch the left hand forward to meet and hit the face of the right fist when turning the body, make a sound. Slightly bend both arms.

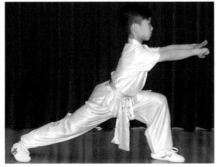

圖 43

32. 分手收抱 (貽親羞) Separate hands withdrawing

(1) 身體右轉重心移向右腿 , 右拳變掌向右劃弧 , 左手分掌于體側 , 眼視右手。(圖 44-1)

(1)Turn right and move the center of gravity to the right leg, change the right fist to a palm and arc an circle to the right, separate the left palm to the side of the body, look at the right hand. (Fig. 44-1)

(2) 左腳收于右腳并攏 ; 身體直立 , 兩掌由兩側收抱腰間。眼平視前方。(圖 44-2)

(2) Withdraw the left foot to the right foot and stand side by side; Body upright, withdraw both palms to the sides of the waist from the sides of the body. Look straight ahead. (Fig. 44-2)

要求 : 整個動作要連貫圓活 , 一氣呵成。轉身 , 分手眼隨右手 , 并步收抱要甩頭 , 眼看前方。

Requirements: The whole movement should be coherent and done in one go. When turning the body, the eyes should follow the right hand when separating the hands, swing the head in folding stance withdrawing, look forward.

收勢 Closing form

兩臂下垂成立正姿勢站立。(圖 45)

Stand in an upright position with the arms drooping. (Fig. 45)

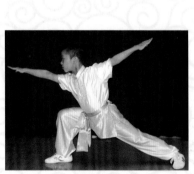

圖 44-1　　　　　　　　圖 44-2　　　　圖 45

鸣谢机构

香港國際武術總會

香港國際文化體育綜合培訓中心有限公司

主編單位：香港國際武術文化中心

策　　劃：于立光

主　　編：于存亮

示　　範：于佳男（幼兒南拳操）

　　　　　李靖熙（幼兒弟子規長拳操、乾坤環、小南拳）

　　　　　林子曦（功夫扇、三字經武術、音樂中國功夫筆）

　　　　　郭君浩（弟子規長拳）

翻　　譯：Chloe Wong（黃倚晴）

香港國際武術文化中心

電話 Tel：(852）95008357

傳真 Fax：25662188

電郵 E-mail:cunliang2012@yahoo.com

香港數碼港數碼港道 100 號 數碼港商場 3 樓 308 鋪

Shop：308, The Arcade,100 Cyberport Road,Cyberport HK

國際武術大講堂系列教程之一
《校園武術》

香港國際武術總會有限公司 出版

香港聯合書刊物流有限公司 發行

國際書號 : 978-988-75078-3-3

香港地址 : 香港九龍彌敦道 525 -543 號寶寧大廈 C 座 412 室

電話 : 00852-98500233 \91267932

深圳地址 : 深圳市羅湖區紅嶺中路 2118 號建設集團大廈 B 座 20A

電話 : 0755-25950376\13352912626

印次 : 2021 年 9 月第一次印刷

印數 : 2000 冊

總顧問 : 冷先鋒

总编辑 : 于立光

責任編輯 : 于存亮

責任印製 : 冷修寧

版面設計 : 明栩成

網站 :www.hkiwa.com　　Email: cunliang2012@yahoo.com

本書如有缺頁、倒頁等品質問題，請到所購圖書銷售部門聯繫調換。